POSTCARD HISTORY SERIES

Center City Philadelphia

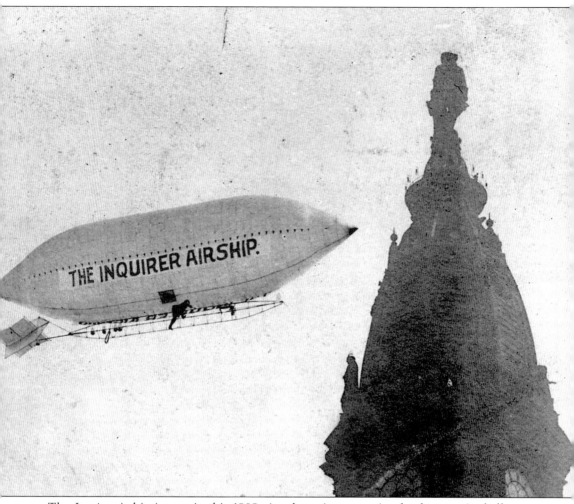

The *Inquirer* airship is seen in this 1908 view hovering precariously close to city hall tower. Notice that a man can be seen hanging from the belly of the ship.

On the front cover: This card offers a panoramic view of south Broad Street during the Roaring Twenties. The marquee of the Bellevue Stratford Hotel is on the left, and city hall stands proudly in the distance. (Author's collection.)

On the back cover: When the Elks convention came to Philadelphia in 1907, this tavern owner, eager to attract customers, lavishly decorated the exterior of his establishment, which was located just above Twelfth and Market Streets. (Author's collection.)

POSTCARD HISTORY SERIES

Center City Philadelphia

Gus Spector

ARCADIA
PUBLISHING

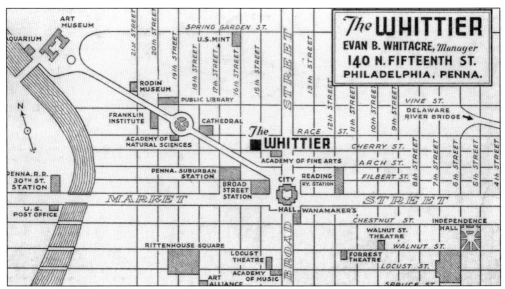

The map in this 1947 advertising postcard details the majority of the streets described in this book.

CONTENTS

ACKNOWLEDGMENTS

I wish to express my wholehearted thanks to the editor of both of my books, Erin Vosgien. She was online with me almost instantaneously whenever I had a question or concern.

I offer many, many thanks to Eileen Wolfberg, who helped me plod through my syntaxes and who offered many eloquent and nitpicky suggestions.

I thank Clarence Wolf for his encouragement and good humor and for the benefit of his historical wisdom.

Most of all, I thank my wife—and best friend—Karen. She should share the spotlight for enduring all of my hours at the computer.

INTRODUCTION

Billy Penn was most certainly a brilliant and organized fellow. His dream of Philadelphia as a "Greene Country Towne" envisioned a city built with geometric precision. It would be unlike those of England or the European continent. There would be no narrow, rambling, serpentine lanes crowded with squalid houses overhanging the streets forever blocking out the sunlight. Instead his surveyor, Thomas Holme, planned a series of streets extending from the Delaware River to the Schuylkill River, a distance of 2.15 miles. These streets would be named according to the custom of English towns, the main thoroughfare being High Street (later Market Street). The named streets, running east and west, would be intersected at right angles with numbered streets, running north and south. The low numbers of the named streets would begin closest to the Delaware River. The northern boundary would be Vine Street, and Cedar Street (now called South Street) the southernmost. A larger boulevard parallel to the north-south streets would be named Broad Street, and would actually be equivalent to Fourteenth Street. The original oblong tract consisted of 1,280 acres. There would be spacious public squares and Friends Meeting Houses interspersed within this grid.

Penn's legendary treaty purportedly occurred in 1682, paving the way for more affable relations with the neighboring Native Americans. Philadelphia's first housing shortage began after 1682 when countless hoards of immigrants descended upon its docks. Philadelphia literally became a tent city, while others suffered through their first winter as cave dwellers. Needless to say, the rigorous climate was too much for many an elderly immigrant.

Areas outside of the city proper were called the Liberties. The Northern Liberties lay north of the city, and the Western Liberties were to the west of the Schuylkill River. Individuals could petition for and purchase parcels of land in these undeveloped, untamed woodlands.

The city continued to grow in an exponential fashion. In April 1845, the legislature passed a new police act requiring the city of Philadelphia and outlying districts of Spring Garden, Northern Liberties, Kensington, Penn, Southwark, and the township of Moyamensing to maintain police forces that could be called upon to suppress possible public riots. Any or all of these militias could be summoned at a given time.

The city of Philadelphia was incorporated in 1854. Prior to that time and dating back to 1790, houses were given consecutive numbers. This meant that buildings on the north side of Market Street (and its parallel streets) were assigned odd numbers (one, three, five, seven, and so on), while those on the south side of the street received even numbers. The building numbers might continue ad infinitum and did not take into account their positions between the numerically named streets (Second Street, Third Street, and so on).

After the consolidation of 1854, the building numbers were reconstituted to correspond to their location between two numerically named streets. In the new scheme, 502 Market Street could be situated only between Fifth and Sixth Streets on Market Street, and 622 Chestnut Street lay between Sixth and Seventh Streets on Chestnut Street. It might be thought that this was confusing to the postmen during this interim period of time, but a John H. Smith might still have received letters with the minimal address of "John H. Smith, City"!

Growing up in Philadelphia, my interest has always been piqued by Philadelphia's Center City, especially its myriad buildings. As a youngster wandering around downtown, I was enthralled by the area but had no concept of its history and the importance of its architecture. This book attempts to provide both the social and architectural history of this vital part of the city through postcards from my personal collection dating from 1900 to 1947 (arranged geographically, not chronologically).

For purposes of this book, I have chosen postcard views of Center City from Market Street and the several named streets to the north and south of it, namely Arch, Race, Vine, Chestnut, Walnut, Locust, Spruce, and Pine Streets, and from the Delaware River to the environs of the art museum. Various locations on Broad Street have either been included within the individual chapters of the named streets or in Chapter 8, which specifically highlights Broad Street.

Although I realize that the portion of the city considered the Rittenhouse Square area is quite large, the reader will find a separate chapter describing the actual environs of the square named after the brilliant first Colonial director of the United States Mint, David Rittenhouse.

There are obvious gaps and omissions in this book. The reasons are quite simple. It would be impossible to include every card in my collection pertaining to Center City Philadelphia, and postcards for every location do not exist.

I sincerely hope that you enjoy this visual tour of Center City Philadelphia as much as I enjoyed compiling it.

One

ANCIENT HISTORY

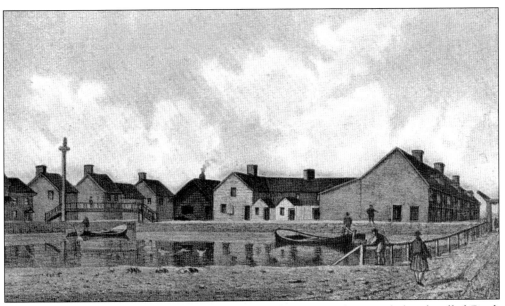

In 1682, William Penn sailed from Chester, Pennsylvania, to a low, sandy beach called Dock Creek. The Blue Anchor Inn was situated on this site, and it was here that Penn received his first taste of local hospitality. For many years thereafter, Dock Creek remained a blighted bog, although it was only a short walking distance from Third and Chestnut Streets, a thriving part of town in the 18th century. A large pond, confluent with the creek, made portions of High (Market) Street impassable.

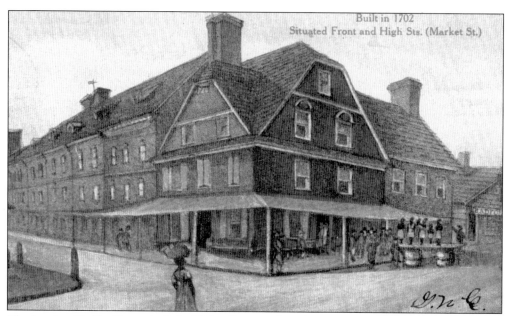

Built in 1702
Situated Front and High Sts. (Market St.)

The London Coffee House, built in 1702 at Front and High Streets, became the busiest gathering place in the city. It was frequented by four Philadelphia businessmen, including Robert Morris, who congregated there to create the foundation of America's financial system in 1754. After a long succession of owners, the coffee house was demolished in 1883.

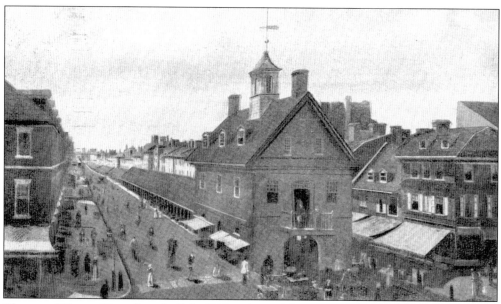

The great "Towne House" was built in 1707 in the middle of High Street, west of Second Street. It served both as a courthouse and market sheds. Erected 28 years before Independence Hall, it was considered to be America's most handsome public building. The courthouse was demolished in 1837 and the sheds around 1860.

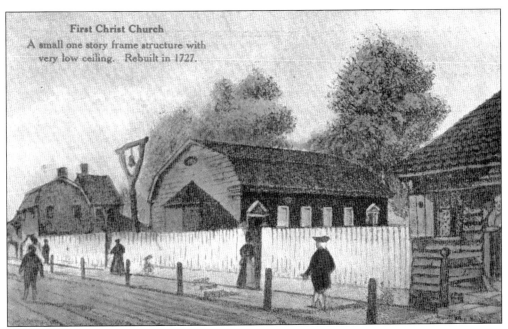

First Christ Church
A small one story frame structure with
very low ceiling. Rebuilt in 1727.

This 1906 postcard shows the original wooden structure of Christ Church, built in 1695 and located on Second Street just north of Market Street. Of the 4,000 people who died during the 1793 yellow fever epidemic, 398 were interred in the Christ Church burial ground.

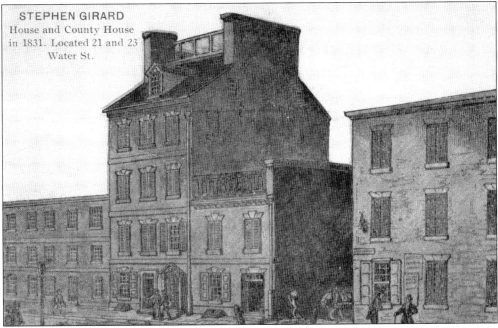

STEPHEN GIRARD
House and County House
in 1831. Located 21 and 23
Water St.

Stephen Girard amassed great wealth as a result of shrewd investments during and after the War of 1812. After his death in 1831, $6 million (around $109 million in 2006 dollars)—the residuum of his fortune—was earmarked for the founding of Girard College. This early postcard shows Girard's home near Front Street. It was later razed to make way for the Market Street elevated train line.

It is now generally agreed that Thomas Jefferson drafted the Declaration of Independence within his lodgings at the southwest corner of Seventh and Market Streets. He chose this site because of its relative isolation and quietude, with only a few other buildings nearby. This postcard from 1908 provides a conceptualized version of the famous post–Revolutionary War corner (the original structure was torn down in 1883).

An exact location is not identifiable in this artist's concept of High Street in 1799, but it was probably situated near Fifth or Sixth Street since the High Street market sheds were barely visible in the distance. Market Street was home to many Philadelphia notables and elegant business establishments.

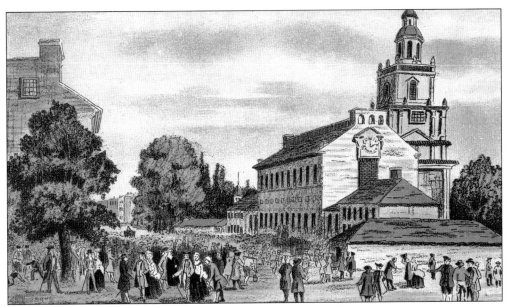

The corner of Fifth and Chestnut Streets was the western limit of the city when land was purchased in 1730 for purposes of erecting a statehouse. The original building was occupied, seen in a 1735 artist's depiction of the area used for this 1906 postcard, and the tower was built in 1750. The steeple was added in 1753 and removed in 1781. The bell tower, designed by William Strickland, was erected in 1828.

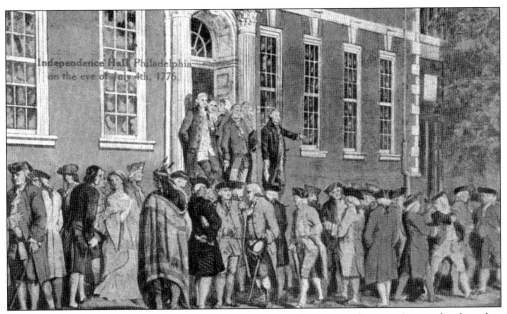

The Fourth of July was acclaimed officially as Independence Day because it was the date that the Declaration of Independence was finally ratified by John Hancock and Charles Thompson. The document was widely distributed via the July 6 edition of the *Pennsylvania Evening Post*, which printed the first newspaper rendition, and the first public reading took place outside of Independence Hall on July 8, 1776.

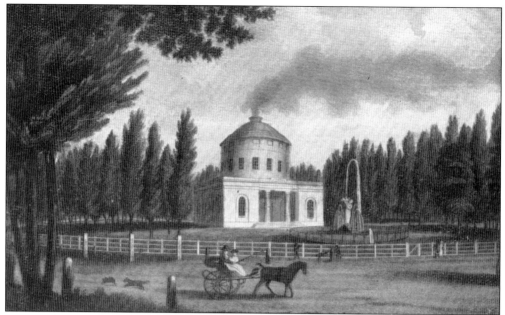

In 1685, the area surrounding Broad and Market Streets was a densely overgrown forest. However, by the end of the 18th century, it had been transformed into beautiful Center Square by famed architect and engineer Benjamin Latrobe. This lovely building served as the city's waterworks, pumping station, and resplendently manicured public square.

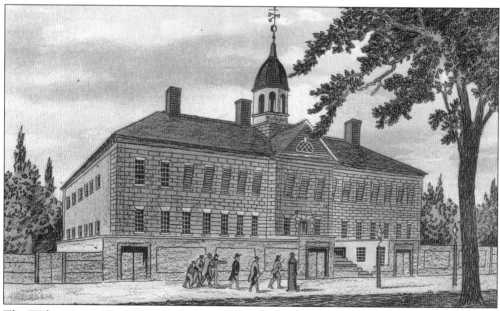

The Walnut Street Gaol (jail), built during the years 1773 through 1776, was located between Walnut and Prune (now Locust) Streets on Sixth Street. It was the world's first penitentiary, and inmates convicted of serious transgressions were sentenced to solitary confinement and hard labor in the hopes that they would achieve repentance. The jail was demolished in 1835.

Two

ON THE DELAWARE
RIVER WATERFRONT

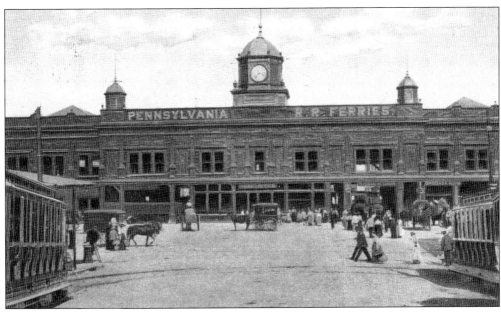

The Market Street waterfront was, since colonial times, the city's most important economic resource. This *c.* 1905 postcard provides a view of the Pennsylvania Railroad Ferry terminal. There being no bridge spanning the Delaware River at that time, ferries transported as many as 200,000 passengers on a Saturday afternoon to trains bound for Atlantic City and Cape May from the Camden, New Jersey, wharf.

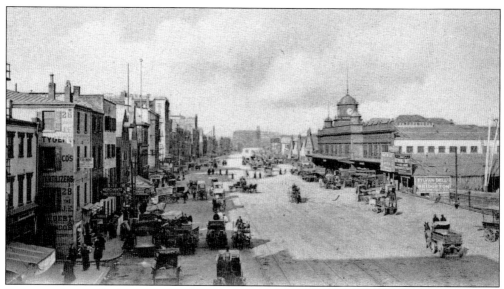

Delaware Avenue looking northward from Chestnut Street was a busy thoroughfare in 1902. Drays skirted the edges of the avenue, many of them laden with bananas, while train tracks dominated the center of the road. The Market Street elevated train did not yet exist, as evidenced by this early photograph.

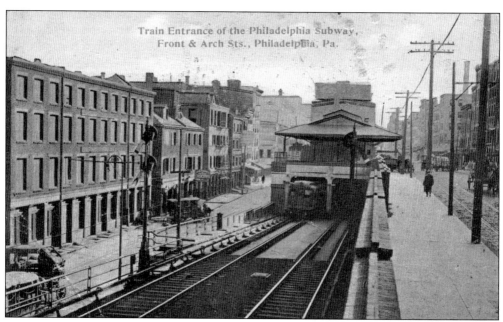

The Market Street Elevated and Subway was a major undertaking and a miracle of engineering skill. Having little knowledge of what might exist below street level meant that the majority of the excavation had to be accomplished with pick and shovel. Opening of the Front and Arch Streets portal began in June 1907. This postcard is dated 1911.

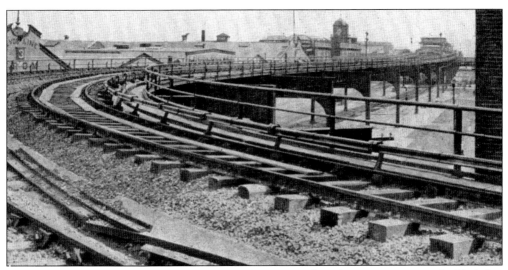

While the Market Street portion of the train line was to be subterranean, it was decided that the Delaware Avenue section had to be elevated due to the topography of the waterfront. An elevated loop was constructed so that the train exited the portal at Front and Arch Streets, made a 180-degree turn, returned south toward Market Street, and then continued to the terminus at South Street.

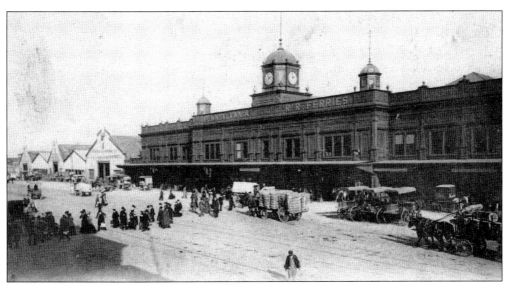

Prior to his death in 1831, Stephen Girard bequeathed $500,000 (around $9 million in 2006 dollars) for the expansion of the Delaware waterfront and the creation of a tree-lined boulevard. This 1912 postcard gave an overview of the crowded condition of Delaware Avenue at the foot of Market Street. Girard would have been hard pressed had he viewed this scene.

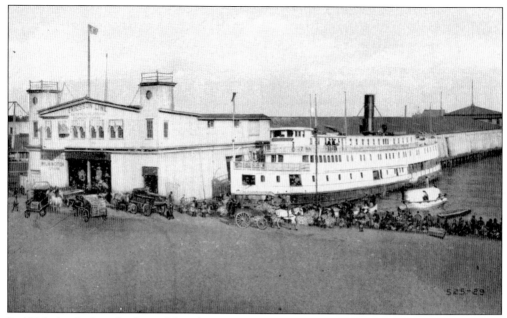

In 1906, the dock at the foot of the Chestnut Street wharf was a beehive of activity. An Ericsson Line steamship, pictured here, ferried passengers to Wilmington, Delaware, and Baltimore, Maryland, on a daily basis.

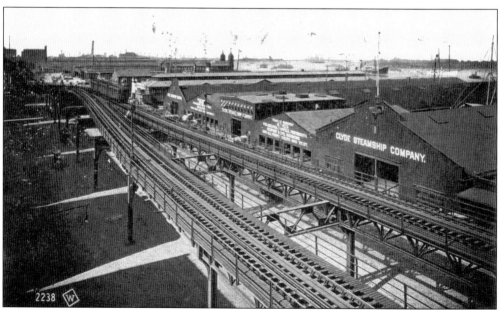

This 1913 shot was taken north of Market Street. Massive steamboat wharf buildings and warehouses hid the Delaware River from view. The elevated trains would eventually carry passengers from the Market Street terminus to Sixty-ninth and Market Streets.

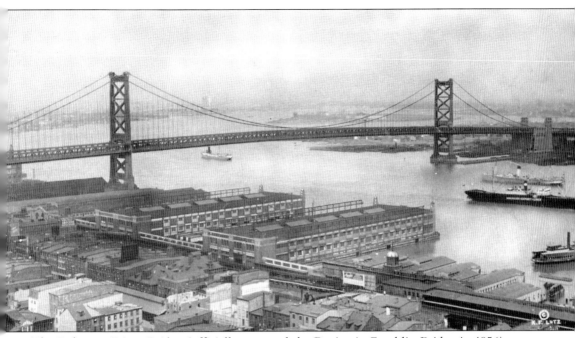

The Delaware River Bridge (officially renamed the Benjamin Franklin Bridge in 1956) was completed in 1926. Extending from a point between Vine and Race Streets, it was one of the world's longest single-span suspension bridges. Designed by Ralph Modjeski, it was 1.81 miles long, utilized over 22,000 miles of wire, and contained 320,000 cubic yards of masonry. This 1936 photograph by K. F. Lutz showed the span of the bridge from the Philadelphia side reaching over to Camden, New Jersey.

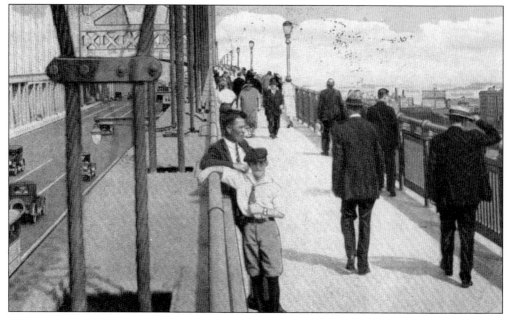

The bridgework was provided with a high-speed track and a trolley track on each side, as well as a pair of 10-foot-wide pedestrian footpaths.

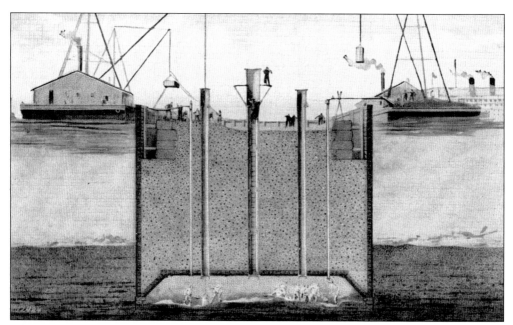

This *c.* 1926 postcard shows the manner in which the bridge's sunken river piers were constructed.

Another 1936 K. F. Lutz real-photo postcard clearly demonstrates the approach to the bridge. The highest water tower just to the right of the bridge belonged to the Whitman's Candy factory.

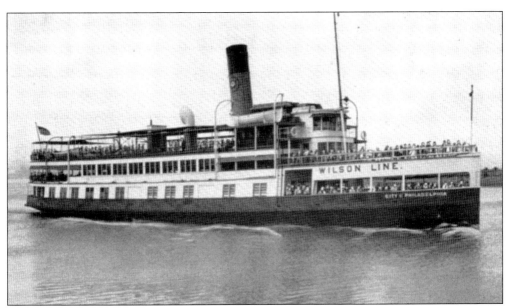

The Wilson Line transported passengers from Philadelphia to Wilmington, Delaware, and also, until 1961, to Riverview Beach Park in New Jersey. Seen here is an early 1940s view of the Wilson Line's *City of Philadelphia*.

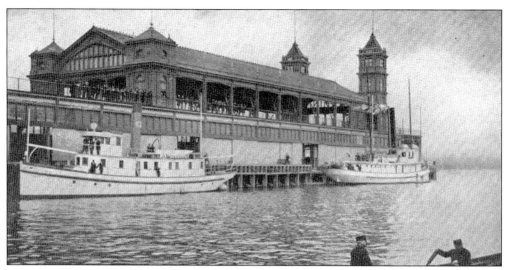

The Race Street Recreation Pier was captured in this 1916 view.

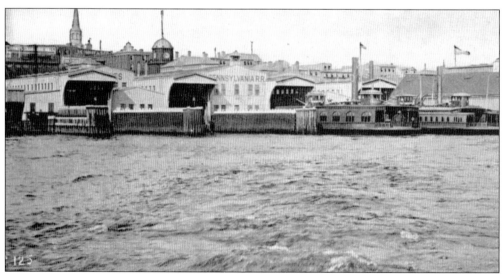

The Market Street ferry docks are seen from the riverside in this card postmarked 1915. After completion of the Delaware River Bridge, the ferries no longer were an essential means of transportation to New Jersey, and the docks eventually faded—or actually, collapsed—into oblivion.

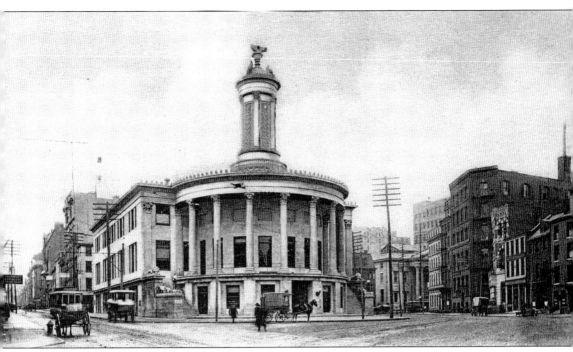

The Merchant's Exchange building, seen in this 1904 postcard, was resplendent with its classic Corinthian colonnades, designed by architect William Strickland. Completed in 1834, this Dock Street landmark provided a meeting place for merchants to barter or sell their merchandise. The headquarters of the Free Society of Traders was located here. The name Society Hill was derived from this organization, having nothing to do with high society or snobbery.

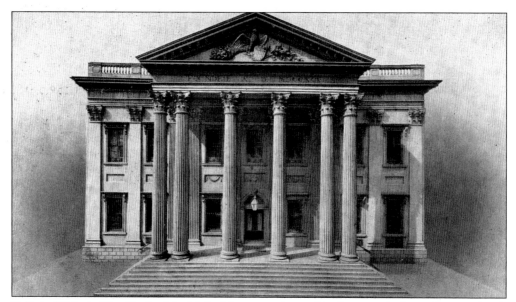

Built in 1795, the First Bank of the United States was located in close proximity to the Merchant's Exchange building. Stephen Girard purchased the bank in 1815 and oversaw its operations until his death in 1831.

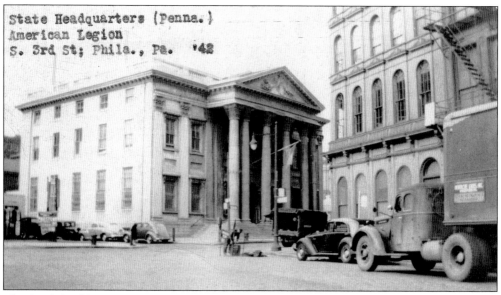

State Headquarters (Penna.)
American Legion
S. 3rd St; Phila., Pa. '42

The bank building was utilized as the Pennsylvania state headquarters of the American Legion 111 years after Girard's death. This 1942 real-photo postcard reveals how the area had metamorphosed into commercial usage.

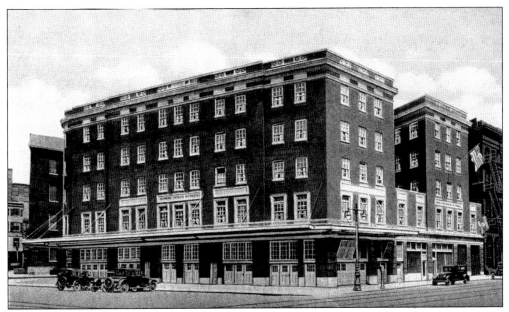

The Seamen's Church Institute was located on the corner of Dock and Walnut Streets. The building was erected in 1925, as seen in this 1928 view. The institute had lodging for over 200 seamen, as well as an employment office, a savings department, and a restaurant.

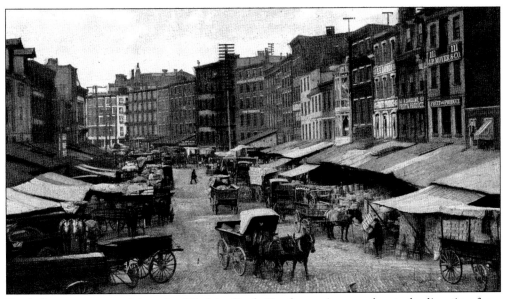

Dock Street, now overlying the filled-in Dock Creek, ran in a southeasterly direction from Second and Walnut Streets to the Delaware River. Originally a residential area, it evolved into a polymorphous conglomeration of business facades. This 1904 postcard shows its serpentine configuration.

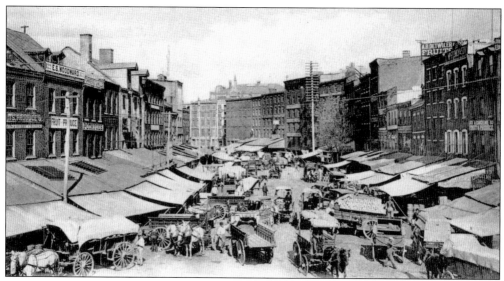

On market days, hundreds of vehicles made the roadway nearly impassable. With the advent of the automobile and truck, Dock Street was a land-locked dinosaur. In the late 1950s, the Food Distribution Center in South Philadelphia became a reality and the Dock Street buildings were demolished.

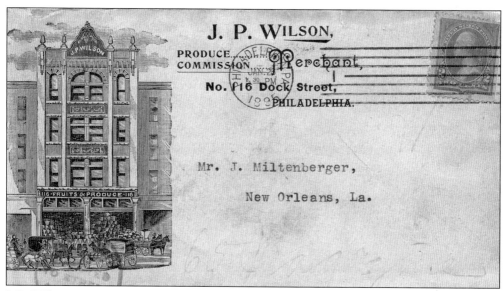

J. P. Wilson was a commission merchant whose business was located at 116 Dock Street. His building was typical of the area, as seen on this envelope mailed to New Orleans, Louisiana, in 1895.

Three

A STROLL DOWN MARKET STREET

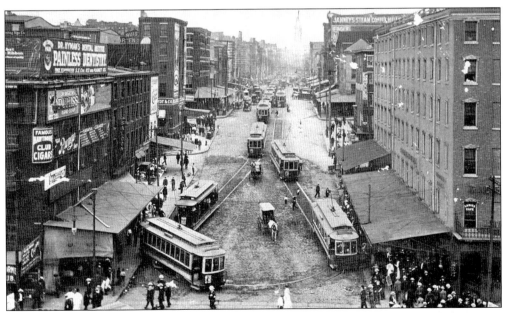

The photograph on this 1902 postcard was probably taken from the top of the Market Street ferry terminal. The loop at the easternmost end of Market Street allowed the newfangled electric trolleys to reverse their course and travel back towards city hall. Note how the once-proud dwellings had been reduced to storefronts with overhanging awnings, the buildings awash with garish signs. A throng of passengers awaited the eastbound trolley to complete its loop so that it could board heading in the opposite direction.

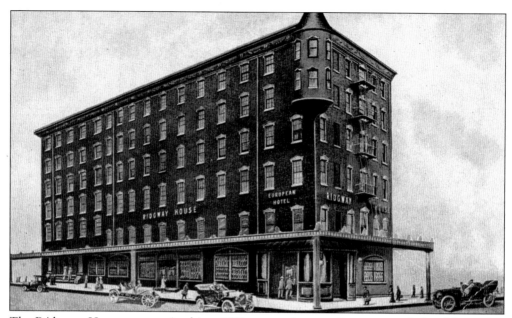

The Ridgway House, as seen in this *c.* 1911 postcard, was a European-style hotel located at the foot of Market Street "at the ferries." The building was originally owned by a company of grain and flour merchants, and converted into a hotel prior to 1840. It was considered a lower class hotel.

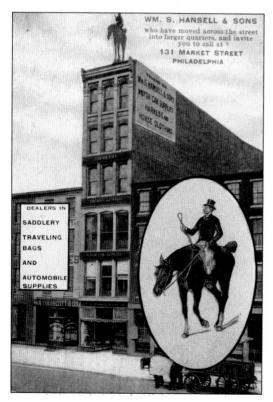

William S. Hansell and Sons was founded in 1810 and produced exquisitely hand-fashioned saddlery implements. With the advent of the automobile, they focused upon automobile interiors. The six-story building, its rooftop brandished by an elegant horse and rider, was located on the north side of Market Street, near Front Street, as seen in this postcard from 1914.

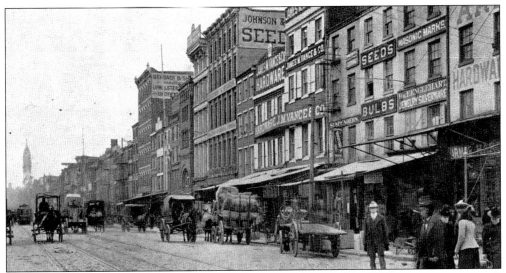

The Johnson and Stokes Seed Company can be seen in the middle ground of this 1905 postcard. The J. M. Vance and Company hardware store, then located at 211 Market Street, is to its right. The small thoroughfare at the rear of these stores was named Church Alley because it abutted Christ Church.

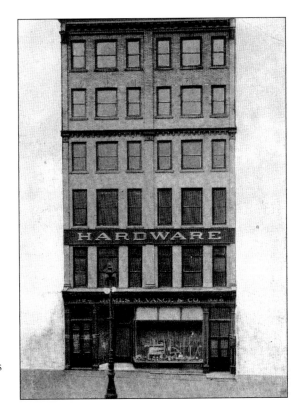

The J. M. Vance and Company hardware store proudly announced, "Come in and inspect our new quarters at 324 and 326 Market Street," in this card postmarked 1910.

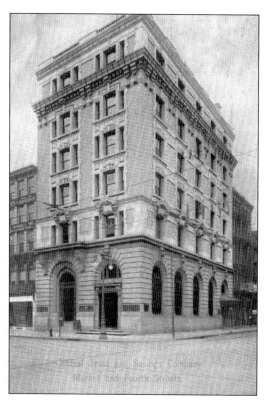

The Central Trust and Savings Company was located on the northwest corner of Fourth and Market Streets. This advertising card postmarked 1910 boasts that the bank's capital and surplus was a princely $1,125,000 (around $24.3 million in 2006 dollars).

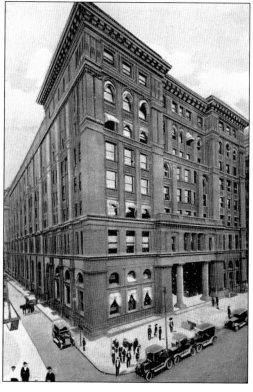

The Bourse building, one of the world's first steel-framed structures, was erected in 1895. Located on Fifth Street, just south of Market Street, it was home to a stock exchange, grain trading center, and maritime exchange. Completely renovated in 1982, the central space now opens up into a 10-story atrium and food court.

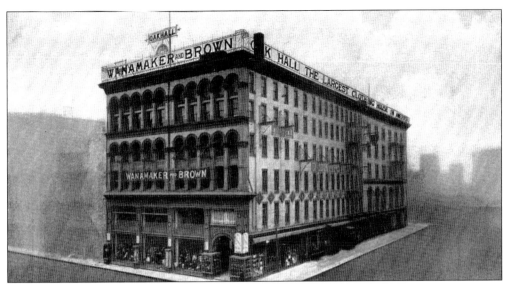

The Oak Hall clothing store, located on the southeast corner of Sixth and Market Streets, was the brainchild of two young enterprising gentlemen, John Wanamaker and Nathan Brown. Opening in 1861, Wanamaker exhibited a great gift for merchandising, and by 1865, Oak Hall appeared at the top of every page in the Philadelphia city directory.

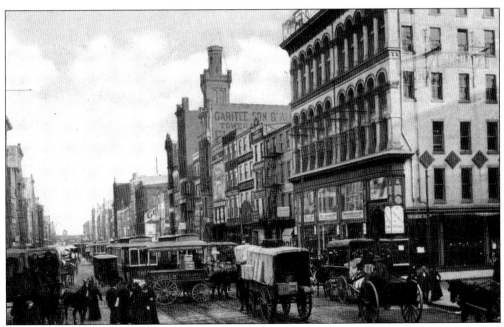

Oak Hall can be seen again at the far right of this 1905 photograph. The tower of Garitee and Son, Wanamaker's chief competitor, loomed skyward in the middle of the block at 518 Market Street. The apparently insurmountable traffic jam at Sixth and Market Streets may well have been staged for the camera.

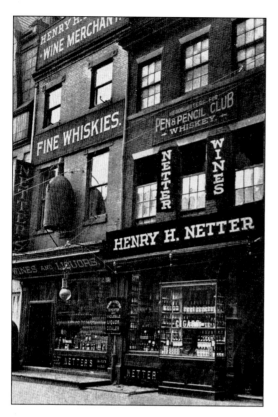

In 1785, Richard Randal owned 704 Market Street and Jacob Carter owned 706 Market Street. In this 1904 view, Henry H. Netter's establishment transformed the two adjacent dwellings into one store. Note the giant whiskey bottle jutting out from the second floor facade.

In 1883, the historic site where Thomas Jefferson wrote the Declaration of Independence was demolished to make room for the Penn National Bank (pictured here), designed by the famous architect Frank Furness. The bank was razed in the 1930s and replaced by a fast-food restaurant.

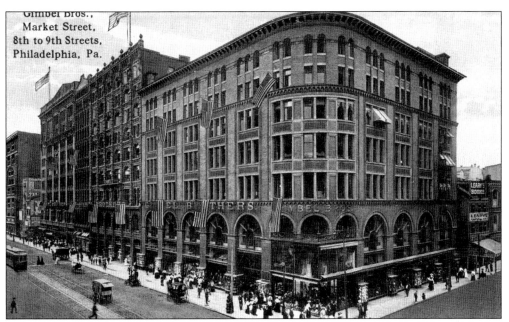

Gimbel Brothers opened their Philadelphia store in 1894 in the block between Eighth and Ninth Streets on Market Streets. This 1908 postcard shows the huge building during its heyday. In 1949, Gimbels advertised, "Would you like to shop without cash? Stop fretting over C.O.D.'s." With that, the store's credit card was born. The last Gimbels closed in 1987.

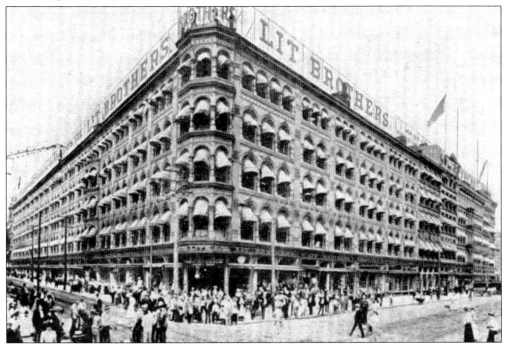

Lit Brothers Department Store was located on the north side of Market Street between Seventh and Eighth Streets, kitty-corner to Gimbels. Built around 1898, it was the first Philadelphia building with a cast-iron facade. Almost 100 years later in 1987, the store closed its doors, and was converted into the Mellon Bank Center.

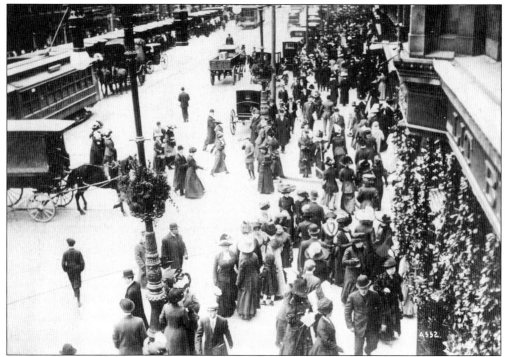

Department store owners were thrilled when Saturdays were warm and fair because customers thronged to Market Street. The dense pedestrian traffic on the sidewalk in front of Lit Brothers Department Store is seen in this 1901 view.

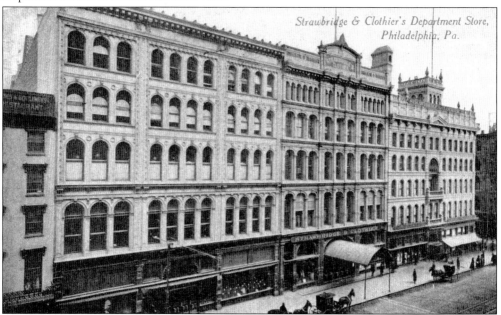

Also on the north side of Eighth and Market Streets was Strawbridge and Clothier's. Built in 1868, its multiple facades are visible in this card postmarked 1913. The store was purchased by the May chain in 1996 and renamed Strawbridge's. May merged with another chain in 2005, shuttering the store in 2006. The building remains unused.

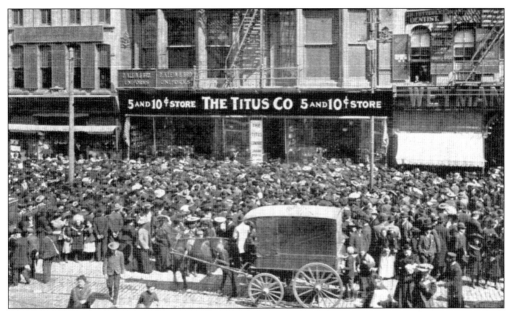

The grand opening of the Titus Store at 925 and 927 Market Street was literally a mob scene. Imagine the human onslaught as its front doors opened for business on April 10, 1905. One wonders what could have been so compelling as to attract so many hundreds of customers.

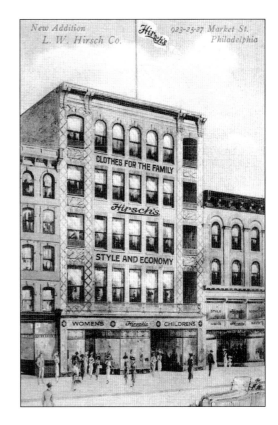

By the early 1920s, the Titus Store had moved out, replaced by and refurbished as the L. W. Hirsch clothing store. Hirsch's full address was 923-925-927 Market Street. The building's facade was altered to accommodate the larger store.

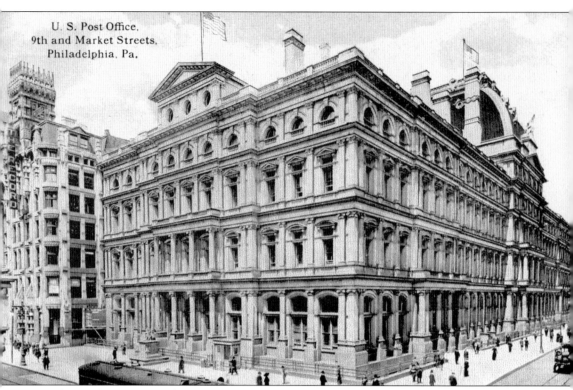

The site between Ninth and Tenth Streets and Market and Chestnut Streets was originally Pres. John Adams's executive mansion. When the government seat was officially moved to Washington, D.C., in 1800, the building was sold at auction and purchased by the University of Pennsylvania. After the university moved to its West Philadelphia campus in 1872, the property was purchased by the federal government to be the site of a post office. Construction of the post office building began in 1873 and was designed by Alfred B. Mullett in the Second Empire style. It took 11 years to complete.

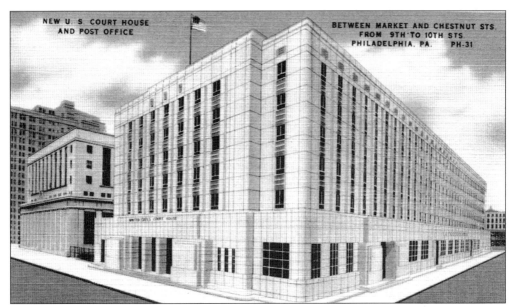

The architect responsible for the new art deco post office was Harry Sternfeld. Built upon the same site as the previous federal edifice seen on page 36, it was erected between 1934 and 1940. The limestone exterior was decorated with relief sculptures of muscular postal workers and other masculine allegorical figures such as Law and Order.

One of Philadelphia's many F. W. Woolworth Company stores was located at 1020 Market Street, as seen in this 1913 view. Woolworth's was one of the first to take advantage of the concept of the five-and-dime store. Rather than sequestering its merchandise behind glass counters, a wide range of items were in full view selling at discounted prices and undercutting those of the local merchants.

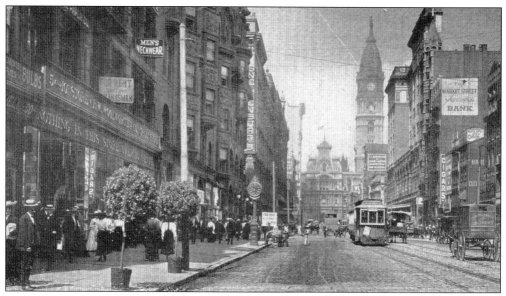

In this *c.* 1907 photograph, Woolworth's is on the left, with the perspective looking westward from Tenth Street towards city hall. Snellenburg's department store can be seen just to the left of center.

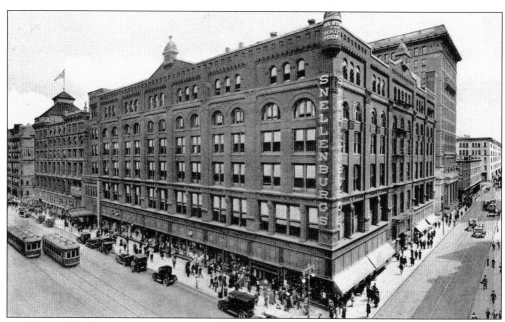

Nathan Snellenburg built his department store in 1894. Like Lits and Gimbels, the Snellenburgs made their employees feel like part of the family. The store, located between Eleventh and Twelfth Streets on Market Street, is seen on this busy 1916 postcard.

This 1920s view shows the United Gas Improvement Company's (UGI) salesroom, situated at the corner of Eleventh and Market Streets. It was erected to display the company's inventory of practical and decorative gas utensils and appliances. The main UGI building was located at Broad and Arch Streets.

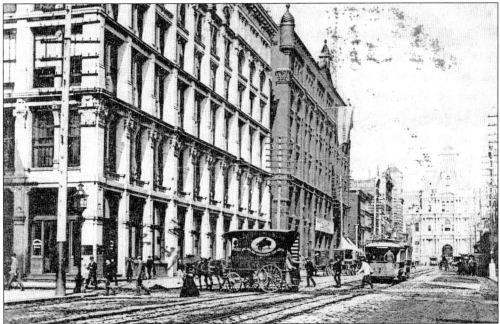

This is an extremely early view of the south side of Eleventh and Market Streets. The postcard is dated May 20, 1901. Incomplete and lacking its trademark tower, city hall can be seen in the far right background. A piano mover's horse-and-buggy are parked at the curbside. Consider how difficult it must have been to hoist a large piano aboard that wagon.

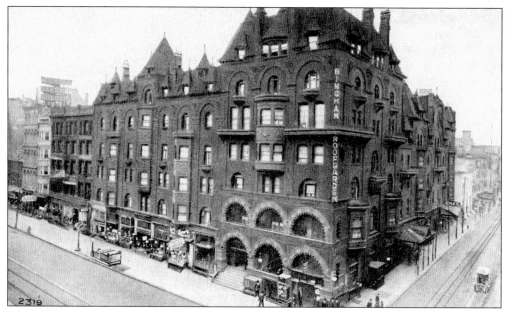

The Bingham House was located on the southwest corner of Eleventh and Market Streets. In its Victorian heyday, the hotel boasted 300 rooms and accommodated 500 guests at $3 per day ($70 in 2006 dollars). By 1920, it was no longer the genteel establishment of yore and was demolished. The Earle Theater was eventually erected on that site.

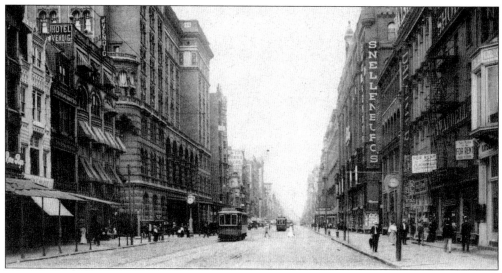

Market Street appears rather barren in this 1905 view. Looking east from above Twelfth Street, the splendid Hotel Vendig can be seen in the left foreground with its windows sporting striped awnings. The original facade of the Reading terminal stood just to its right. Although Market Street was prime real estate at the time, note the several "for rent" signs in evidence.

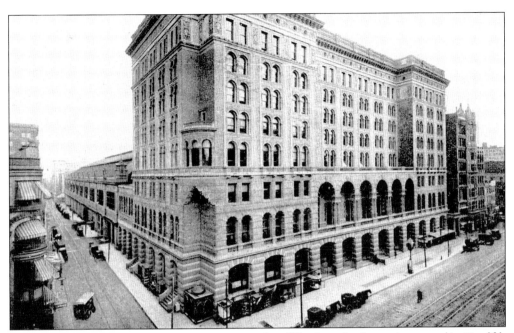

The Reading terminal has undergone numerous face-lifts since the first train entered its Twelfth and Market Streets portals in 1893. Both the Reading Railroad and the terminal closed in 1976. The building was renovated in the 1990s and now serves as a dramatic entranceway into the Philadelphia Convention Center. The terminal building's high vaulted ceiling is identical to the configuration of the original train sheds.

A tour of Market Street would be incomplete without mentioning the Philadelphia Saving Fund Society (PSFS) building at 12 South Twelfth Street. The streamlined skyscraper, created by architects George Howe and William Lescaze, was built between 1929 and 1932 and reached a height of 38 stories, or 491 feet. PSFS bank was liquidated in the 1980s and the structure was converted into a three-star hotel.

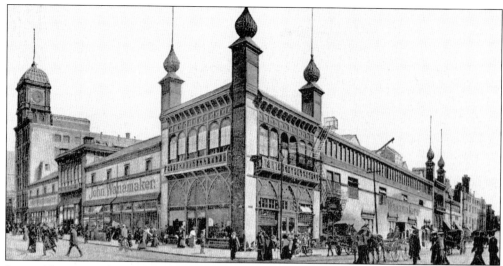

Located between Thirteenth and Broad Streets on Market Street, John Wanamaker opened his Grand Depot in 1876, just in time for the centennial exposition that same year. It can be seen in this 1904 postcard. The building was a refurbished railroad station, and the business operated under the principle that all goods were sold retail and any item could be returned.

Prior to the opening of the Grand Depot, Wanamaker allowed evangelist Dwight L. Moody to utilize his building as a meeting place. Wanamaker ensured that Moody's meetings would be adequately staffed by providing store personnel as ushers.

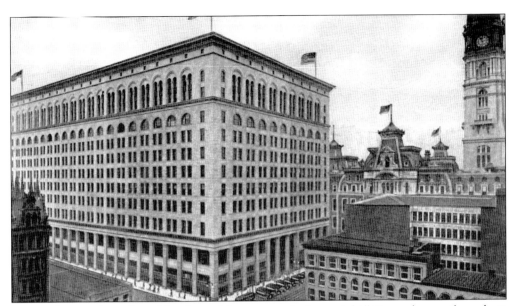

Wanamaker was the author of the phrase, "the customer is always right." He was known throughout the city as setting the highest standards in business ethics. Wanamaker's new department store, opened in 1911, is shown in this postcard from 1918 in relationship to the surrounding cityscape. City hall can be seen to the far right.

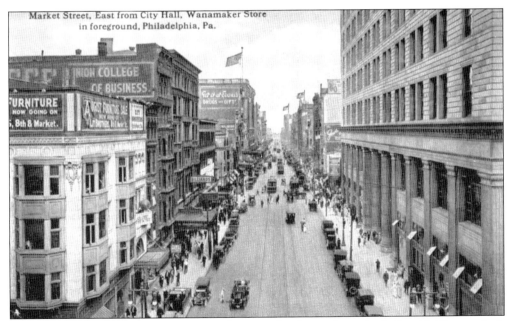

This 1916 postcard is a panoramic view of east Market Street from city hall, with Wanamaker's store in the right foreground. Numerous automobiles line both sides of the street since "No Parking" signs were obviously not yet in vogue.

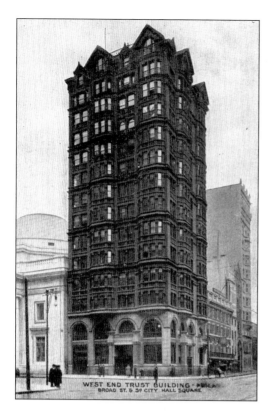

This postcard of the West End Trust building, located on Broad Street near south Penn Square, was printed in 1908. In 1918, the West End Trust Company published its capital and surplus as being $4 million (around $60.9 million in 2006 dollars). The building was eventually razed to make way for the Girard Bank complex (renovated at the beginning of the 21st century into what is now a Ritz-Carlton hotel).

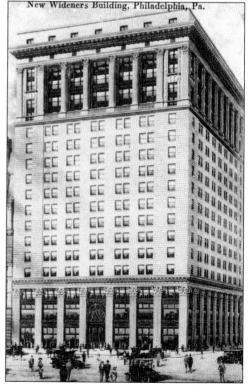

The Widener building, also on south Penn Square, was designed by the famous architect and philanthropist Horace Trumbauer and erected in 1914. Additions and alterations were made over the years, and the building still stands in the shadow of city hall.

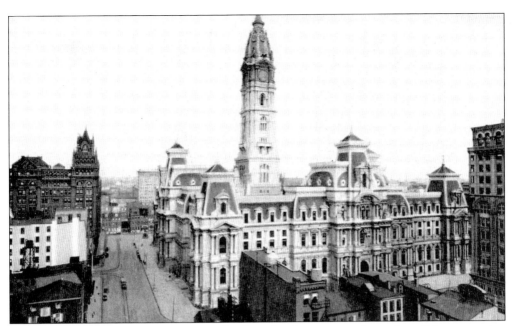

City hall, located on Penn Square at Broad and Market Streets, once deemed a garish monstrosity, is now regarded by many as possessing remarkable artistic appeal. Its cornerstone was laid on July 4, 1874, and the last block of marble was placed on the tower in 1887. At the time, it was the tallest building in Philadelphia. It is seen in this postcard from 1911.

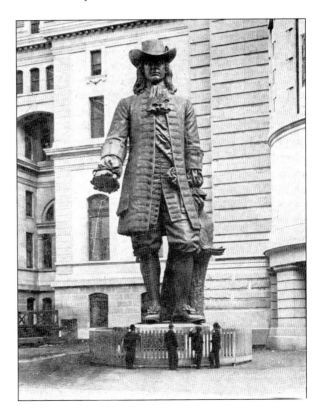

The gargantuan statue of William Penn, sculpted by Alexander Milne Calder, remained on public display in the courtyard prior to being hoisted to the pinnacle of city hall. At a height of 37 feet and a weight of 27 tons, its placement in 1894 was certainly a prodigious feat.

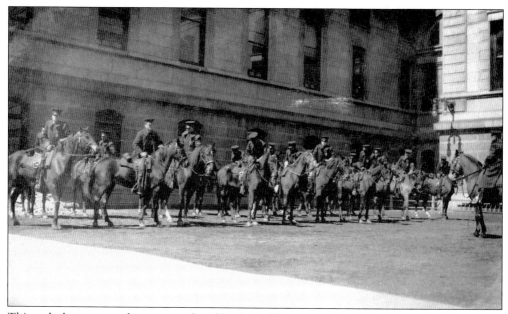

This real-photo postcard was snapped within city hall's courtyard in 1910. The stately Philadelphia mounted police, dressed in their finest attire, are seen in rigid formation.

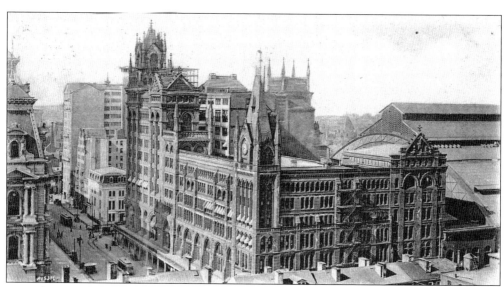

Legendary architect Frank Furness's unique signature was certainly identifiable in the 1881 design of the Pennsylvania Railroad's Broad Street station. Although an architectural landmark, it was highly responsible for smoke and noise pollution as trains rumbled through the busy Center City district. This postcard is dated November 1906.

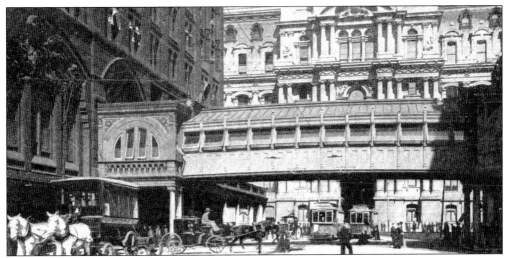

An aboveground walkway spanned the area between the railroad station and the buildings across the street. City hall is visible in the center background.

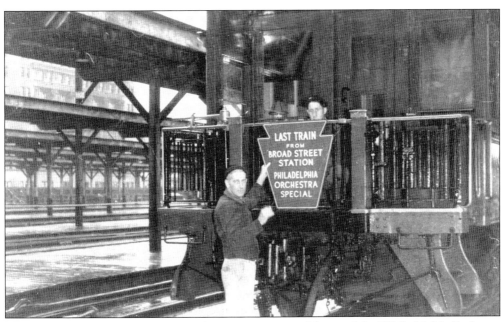

In 1952, the last train to leave the Broad Street station was nicknamed the "Philadelphia Orchestra Special," as the orchestra attended the closing (the man in front of the train was an orchestra member). The station was razed in 1953 to make way for the Penn Center commercial complex and later the 54-story Mellon Bank Center.

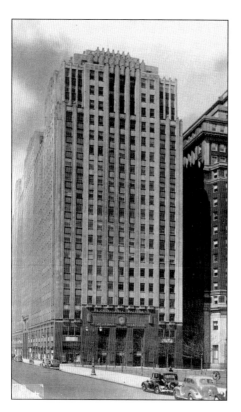

Between 1920 and the 1930s, the Pennsylvania Railroad constructed a more modern facility just two blocks west of city hall, dubbed Suburban Station. This 1938 postcard, by the famous Philadelphia photographic historian K. F. Lutz, advertised the station as being capable of handling 50,000 commuters and 325 trains daily.

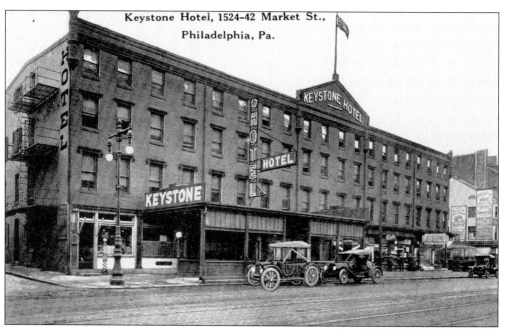

The Keystone Hotel, located at 1524–1542 Market Street, had already seen better days when this image was captured in 1909. The overhang in front of the building was an entrance to the Market Street subway.

Four

CHESTNUT STREET

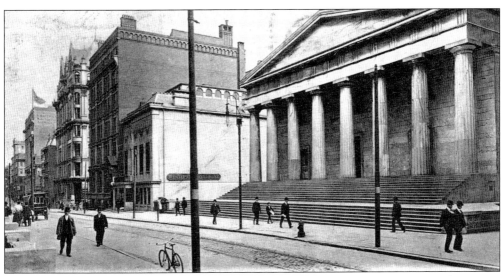

Chestnut Street has always had an air and flavor different from its parallel partner, Market Street. Chestnut Street—known as Chesnut in the early 1800s—was a heterogeneous conglomeration of wholesale stores and financial institutions, interspersed amid edifices of great national historical significance. The Old Custom House, located between Fourth and Fifth Streets on Chestnut Street, was designed by Benjamin Latrobe and modeled after the Greek Parthenon. It was home to the second Bank of the United States from 1824 until 1837. This card also gives an excellent view of the south side of Chestnut Street looking eastward as it appeared in 1907.

The new Custom House, located at Second and Chestnut Streets, was designed by Verus T. Ritter and Howell L. Shay, and completed in 1933, three years before this card was postmarked. The offices of the collector of the Port of Philadelphia, as well as army, navy, and other federal department offices, were located within it.

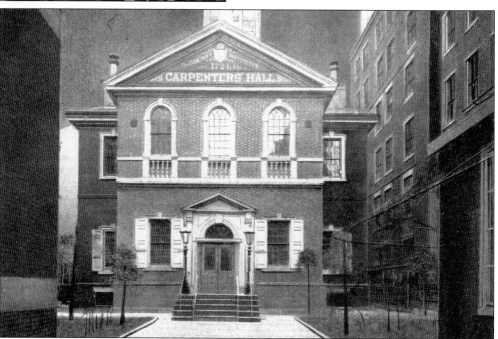

Carpenters' Hall stands in a courtyard on Chestnut Street between Third and Fourth Streets. Designed in the Georgian style and built between 1770 and 1773, it became home to the First Continental Congress in 1774. Although free to the public, it remains under the original ownership of the Carpenters' Company.

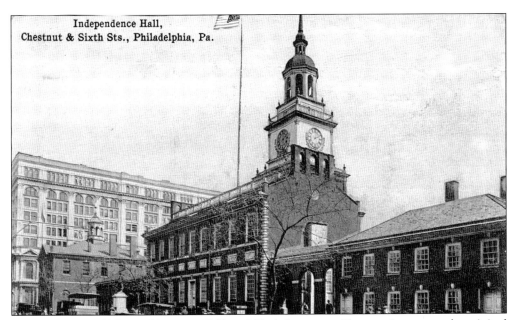

Independence Hall, located between Fifth and Sixth Streets on Chestnut Street, was the original statehouse, the seat of the pre- and post-revolutionary war government. The most crucial days of the new republic were played out within the walls of the building. It was here that the Declaration of Independence was first read aloud to the public.

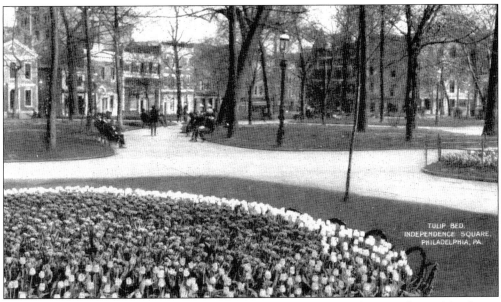

Although postmarked in 1909, the view of Independence Square has not changed in almost 100 years.

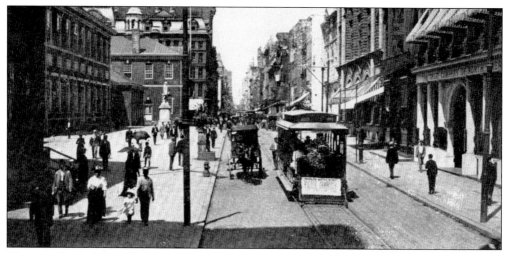

Chestnut Street is seen looking west in this view postmarked 1909. Independence Hall stands on the far left. The Trust Company of North America, one of the many banking institutions along this thoroughfare, is seen at far right.

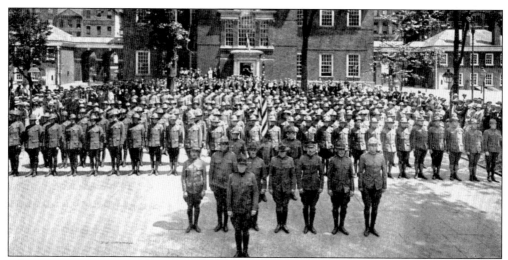

All eyes were on the First Telegraph Battalion Signal Corps of the United States Reserve when this postcard photograph, dated June 18, 1917, was taken.

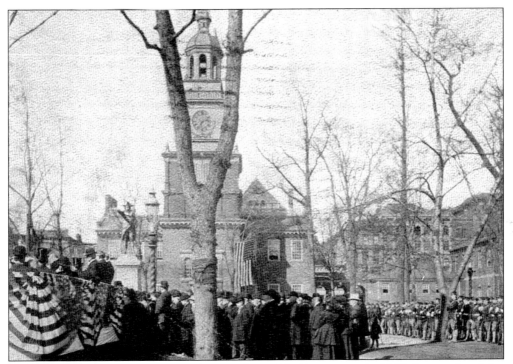

A large crowd gathered to celebrate the unveiling of the Barry statue in 1907. Commodore John Barry was named the "Father of the American Navy."

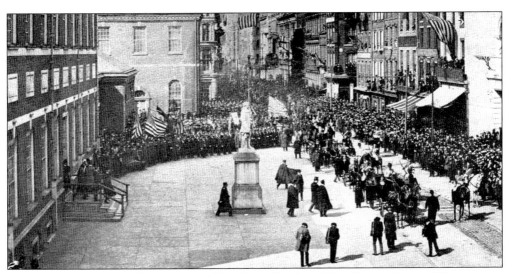

In 1861, the statehouse flag was raised by Pres. Abraham Lincoln on George Washington's Birthday. A plaque memorializing that occasion was embedded in cement just to the rear of the Washington statue, seen in the center of this view. The photograph was taken on July 4, 1907.

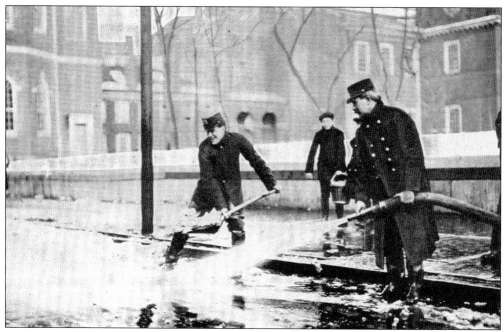

A much less formal view of the rear of Independence Hall was taken on a wintry day in 1907, portraying a smiling street cleaner shoveling snow off of murky Sixth Street.

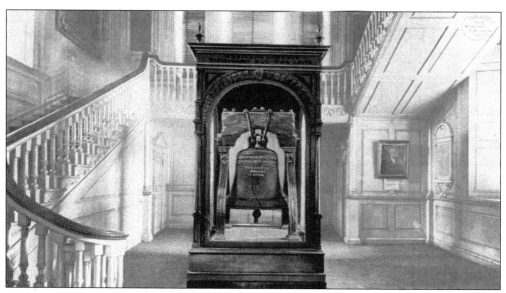

The term Liberty Bell, super-symbol of our nation's freedom, was first coined in an 1837 edition of *Liberty*, a publication of the New York Anti-Slavery Society. The bell initially resided within the vestibule of Independence Hall. It was not encased and could be touched and caressed by all. This postcard is from around 1905.

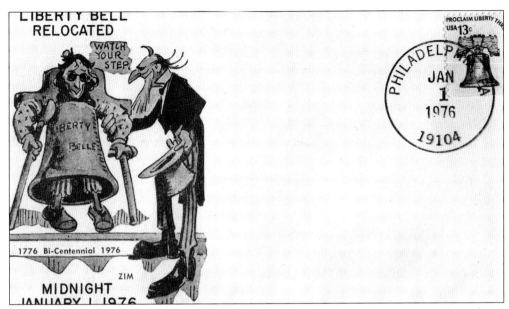

On New Year's Eve 1975, the Liberty Bell was moved to a more secure location on Independence Mall. Pictured is a philatelic souvenir of that bicentennial event. The famous icon currently resides in the Liberty Bell Center, opposite Independence Hall.

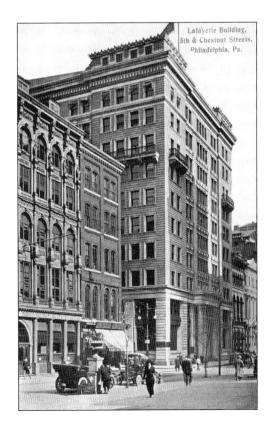

The Lafayette building at Fifth and Chestnut Streets was constructed in 1907 for the offices of the Girard Estate. It is seen in this 1913 postcard view.

This is a 1906 view taken near the corner of Fifth and Chestnut Streets. After the Civil War, a myriad of street-level businesses proliferated in this area.

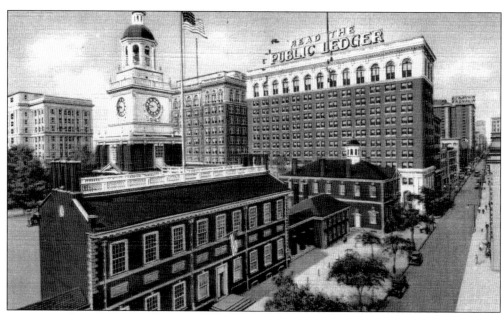

In 1864, George Childs purchased the Public Ledger, one of Philadelphia's oldest newspapers. He moved the Ledger to much larger quarters at Sixth and Chestnut Streets. The building can be seen to the right of Independence Hall in this 1935 postcard.

The Chestnut Street Theater, which opened in 1822, was located at Sixth and Chestnut Streets. It was designed by William Strickland, a prominent architect well known for many other notable Philadelphia buildings. Although demolished in 1855, this 1902 postcard provides a retrospective view of the theater.

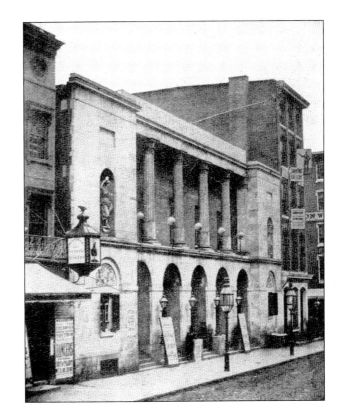

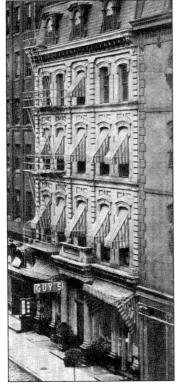

This 1913 postcard gives the illusion that Guy's Hotel was sandwiched between other buildings, although it was actually located at the corner of Seventh and Chestnut Streets. Situated in the more affluent section of east Chestnut Street, the hotel and its bar were frequented by businessmen and bankers.

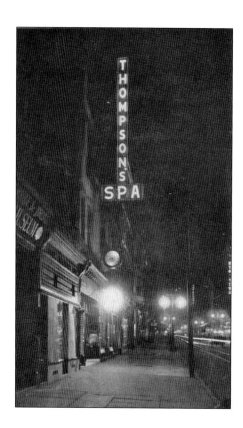

This 1930s nighttime scene was simply titled, "The Home of Thompson's Grape Juice." Thompson's Spa was located at 712 Chestnut Street.

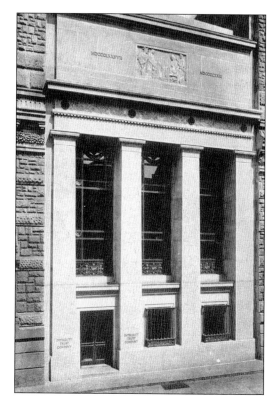

The exterior architecture of the Integrity Trust Company at 717 Chestnut Street was much out of sync with its neighboring buildings.

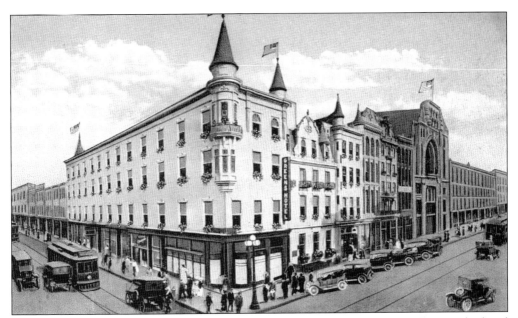

Green's Hotel was located on the northeast corner of Eighth and Chestnut Streets. The hotel that opened in 1866 was once the colonial home of the Shippens, an influential Philadelphia family. In fact, Green's Hotel had preserved the room where Peggy Shippen was married to Benedict Arnold.

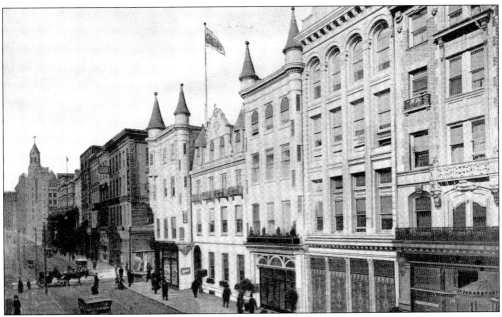

Green's Hotel was especially known for its bar and restaurant and was a prime Philadelphia gathering place. With the advent of prohibition, the bar and the hotel suddenly lost its clientele. The building was demolished in 1934. This card, postmarked 1918, also gives a nice perspective of Chestnut Street.

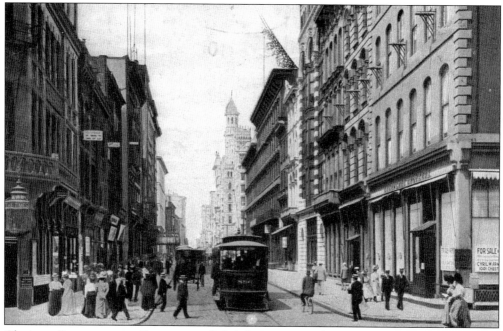

Chestnut Street, as seen from west of Eighth Street, is a bustling business district in this 1906 view.

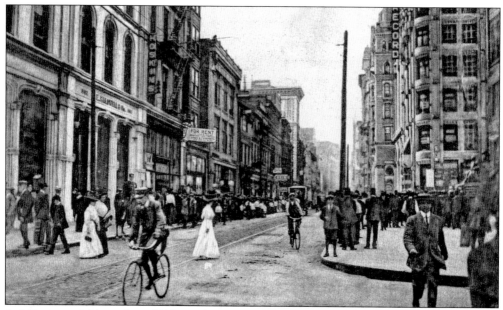

A deliveryman, his teeth probably rattling in his skull, bikes along the cobblestone roadway on Chestnut near Ninth Street. The Record building, home of the famous newspaper *Philadelphia Record*, is seen on the far right.

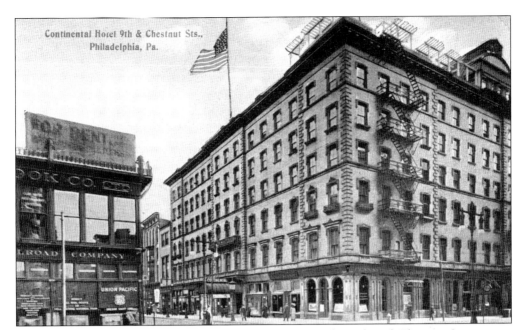

The Continental Hotel, located on the southeast corner of Ninth and Chestnut Streets, was already past its prime when this postcard was delivered in 1913. Opened in 1860, it had 500 rooms. It was said that Abraham Lincoln and Charles Dickens had visited there. The hotel was demolished in 1923.

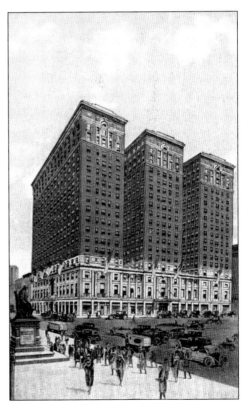

The Benjamin Franklin Hotel was erected upon the site of the Continental Hotel. Designed by Horace Trumbauer in late-18th-century Anglo-American style, it opened in 1925. Its classic interior furnishings and opulent ballroom made for elegant accommodations. It was renovated and reopened in the mid-1980s as the Benjamin Franklin House, containing apartments and office suites.

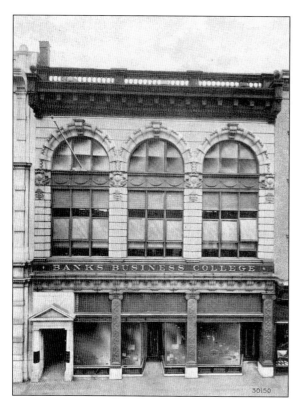

This early 1910 postcard shows the facade of the Banks Business College at 1016 Chestnut Street. It was one of many such institutions in Philadelphia that taught typing, accounting, and librarians' skills. The exterior was reminiscent of any number of storefront businesses in the area. The building no longer exists.

The Chestnut Street Opera House was built in 1870 and quickly became an important legitimate theater in Philadelphia. Located at 1021–1029 Chestnut Street, it eventually evolved into a movie theater. In this photograph, the house marquee displayed an advertisement for D. W. Griffith's *America*, produced in 1924. The theater was demolished in 1940.

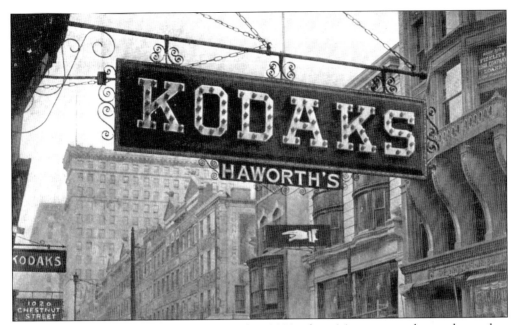

The John Haworth Company, seen in this 1910 advertising postcard, was located at 1020 Chestnut Street. A nice close-up view of some of the buildings on the north side of the block can also be seen.

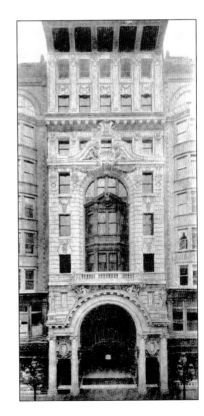

Keith's "million dollar theater" was located at 1116 Chestnut Street. Originally a vaudeville house, it was converted into a movie theater in 1949. Keith's was demolished in 1971. The perspective seen in this 1907 postcard makes the building look rather narrow.

Oppenheim, Collins, and Company, a women's specialty clothier and fur dealer, was located at 1126–1128 Chestnut Street, just down the street from Keith's theater. Oppenheim's store was purchased by Franklin Simon and Company in 1945 and, after a long laundry list of mergers, the trade name was eventually lost.

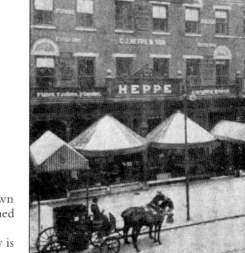

The C. J. Heppe and Son's salesroom was situated just across from Oppenheim's, along the portion of Chestnut Street known as "piano row," which was obviously named because of the large population of piano dealers in the vicinity. This postcard view is from around 1900.

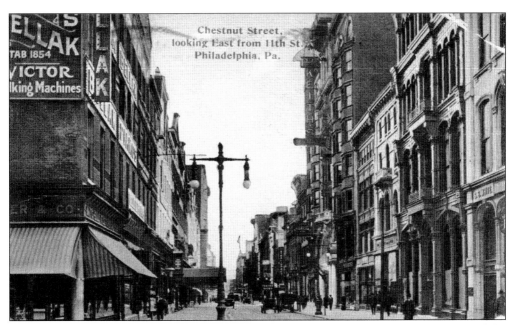

Chestnut Street is viewed looking east from Eleventh Street in this 1905 card. As a sign of the times, the Bellak Piano Store located at 1129 Chestnut Street is seen on the far left, advertising Victor talking machines as well as pianos.

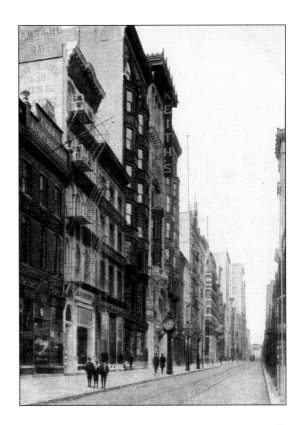

Chestnut Street is seen looking west from Eleventh Street in this 1914 postcard. Keith's theater, in the middle of the block, is the tallest building on the left side of the street.

Hanscom's Restaurant was located at 1119 Chestnut Street, directly opposite Keith's theater, as viewed in this 1908 postcard. Hanscom's, most remembered for its chocolate candy, existed well into the 20th century.

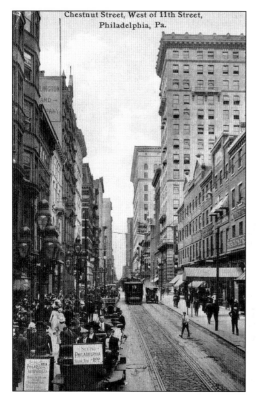

Chestnut Street west of Eleventh Street was the terminus of "Seeing Philadelphia." One could travel about Philadelphia and Fairmount Park and see all of the sites for $1 around 1910, which was not an inconsequential sum of money at that time (around $20 in 2006 dollars).

The Hotel Adelphia, built in 1914, was designed by Horace Trumbauer in the French Renaissance style. Located at Thirteenth and Chestnut Streets, it was 21 stories high and contained 400 rooms. It advertised itself as being "nearest to everything in Philadelphia."

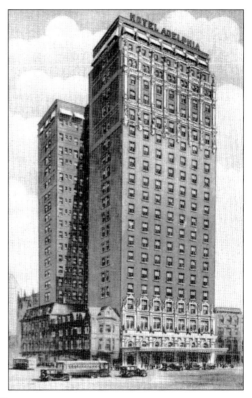

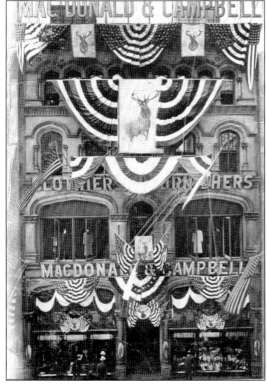

MacDonald and Campbell Clothiers was located at 1334–1336 Chestnut Street, and was mentioned in Baxter's *Panoramic Business Directory* in 1880. It is seen here in 1907 ostentatiously decorated for the great Elks' convention. The store was demolished during the early part of the 20th century.

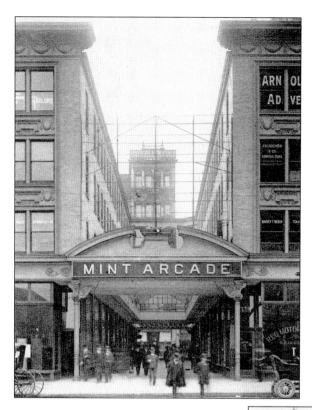

The Mint Arcade, a menagerie of stores adjacent to the second United States Mint, was located at 1331—1337 Chestnut Street. It was built in 1902, shortly before this postcard was printed, and demolished in 1914. With such a short life span, the arcade certainly could not have been a very sound business investment.

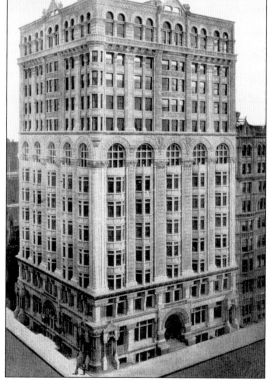

The Betz building, also known as the Lincoln building, was erected in 1892 by architect William H. Decker. It was located at the southeast corner of Broad and Chestnut Streets, as seen in this 1911 postcard. It was demolished in 1926, and replaced by the PNB building.

This 1923 postcard was titled "The Canyon," and portrays Chestnut Street looking west from Broad Street. Except for the colossal Bellevue Stratford Hotel on the left and the Morris Building on the right, one would have to say that this canyon was not very grand.

Kugler's Restaurant was located at 1412–1414 Chestnut Street. The design of its exterior, as seen in this early postcard (around 1910), was a reflection of the ornate decor of its dining rooms. In the era prior to the ban of smoking in city restaurants, an advertisement stated, "Camels are popular in Kugler's. We always keep well stocked with them."

The Republic Trust Company was located at 1429 Chestnut Street, as seen on this card postmarked 1910. The preprinted reverse of the card, signed by the bank president, stated, "This view of our building is good, but we believe in actual contact." A parking lot is now located at 1429 Chestnut Street.

The Colonnade, seen in this 1918 postcard, was originally a group of several residential dwellings known as Colonnade Row, located on the southwest corner of Fifteenth and Chestnut Streets. The houses were combined and upper floors added. The hotel had 200 rooms, 150 with baths, at a price of $1.50 and upwards per day (around $23 in 2006 dollars).

Five

QUIET ON
WALNUT STREET

John Krider was a gunsmith, most famous for his excellent handmade firearms and fishing rods. Originally a residence, the building seen here on the northeast corner of Second and Walnut Streets was erected in 1751 by the Drinker family. The Krider Gun Shop was located here for many years, but after the beginning of the 20th century, it was known as L. C. Siner and Company. A placard commemorating the site where John Drinker, the "first white child in Philadelphia," was born, was once emblazoned upon the outside of the building, which was demolished in 1955.

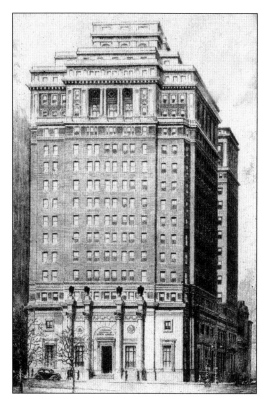

The Insurance Company of North America, founded in 1792, was the oldest American fire and marine insurance company. Located at 411 Walnut Street, it is seen in this postcard dated 1942. The company was owned by the Cigna Corporation until 1998.

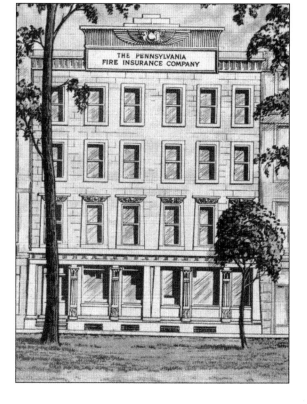

The Pennsylvania Fire Insurance Company was initially a single building at 510 Walnut Street built in 1830. In 1902, 508 Walnut Street was added. The building was demolished in the early 1970s but its facade was preserved as a screen in front of the building. This postcard was created around 1945.

Independence Square is the area to the rear of Independence Hall bounded by Fifth, Sixth, and Walnut Streets. This 1908 advertising card shows a groundskeeper merrily pushing his style K Philadelphia mower with the tower of Independence Hall stretching skyward in the background.

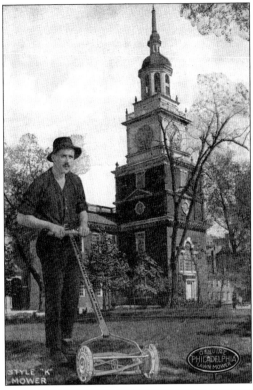

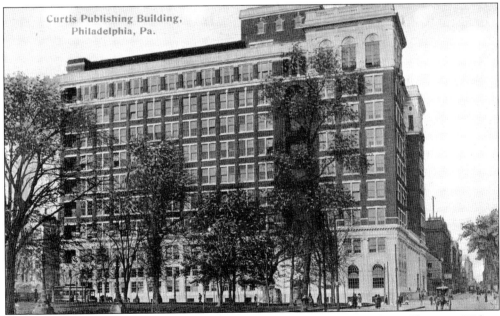

The Curtis Publishing Company, home of the *Saturday Evening Post*, was located between Walnut and Sansom and Sixth and Seventh Streets. The plant, built between 1910 and 1914, employed 4,000 workers maintaining three shifts, boasted over 200 presses, and produced 17 million magazines per month. The building also housed many amenities for its employees. The building was renovated into general office space in 1987 and renamed the Curtis Center.

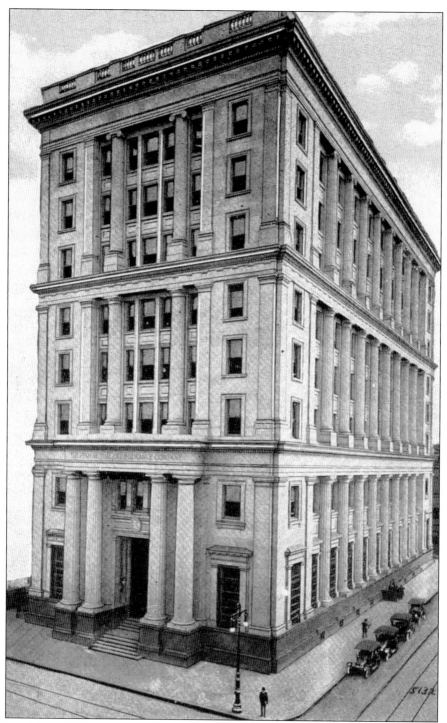

The Penn Mutual Life Insurance Company building is located on the site of the Walnut Street Gaol, at the southeast corner of Sixth and Walnut Streets. The facade, created by architect John Haviland, dated back to 1838. It was incorporated into the 1901 building, as seen in this 1920s postcard. A skyscraper was added in 1931, as was the Penn Mutual Tower in 1970.

The exterior doorway of an old Colonial home is seen in this 1912 view at 712 Walnut Street. This once-grand residence had been transformed into office space for a realtor and several attorneys.

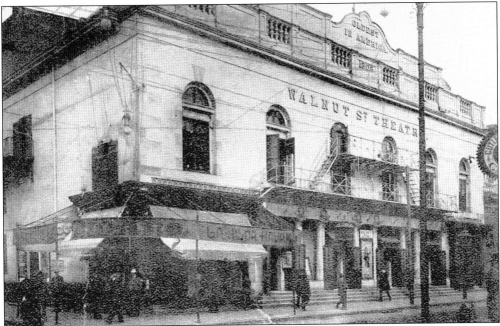

The Walnut Street Theater, located at 825 Walnut Street, is the oldest existing theater in Philadelphia. Built in 1808, it originally functioned as a circus, complete with elephants. This real-photo postcard shows its exterior in 1902. It was the site of the first presidential debate between Gerald Ford and Jimmy Carter in 1976.

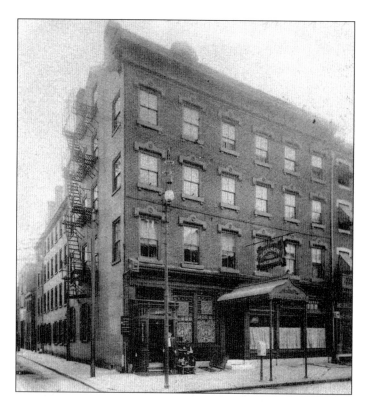

Zeisse's Hotel was a rather dreary-looking establishment at 820 Walnut Street, as seen in this 1904 view. Its clientele was comprised of the thespians of the local burlesque theaters. In 1895, Madge Yorke, a 22-year-old actress, was shot and killed by her drunken lover in her room at Zeisse's.

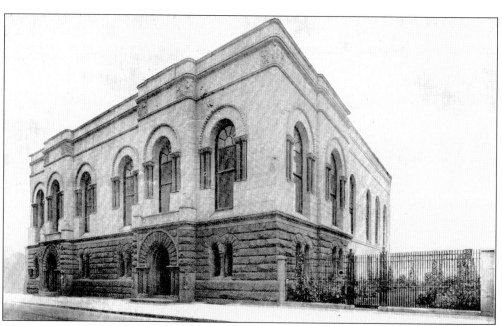

The Western Saving Fund Society of Philadelphia was incorporated in 1847. The building, located at Tenth and Walnut Streets, is seen in this 1912 view. In 1982, on the verge of failure, the bank was taken over by the Philadelphia Saving Fund Society, thus creating the nation's largest savings fund bank.

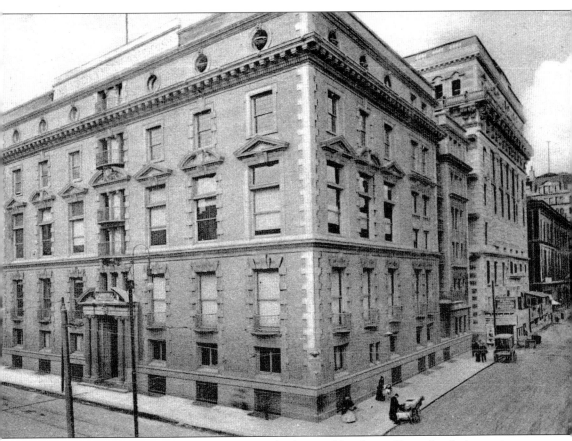

The quiet of Walnut Street has been constantly shattered by the wailing of ambulance sirens. The fledgling Jefferson Medical College, originally part of the medical department of Jefferson College in Canonsburg, Pennsylvania, moved to its site at Tenth and Walnut Streets, as seen in this 1904 postcard. Thomas Eakins's famous painting of *The Gross Clinic* immortalized Dr. Samuel Gross, who held the position of chairman of surgery from 1856 until 1882 at the institution.

The ivy-covered building in this 1902 postcard was a branch of the Free Library of Philadelphia, located on the northeast corner of Thirteenth and Walnut Streets. The library system was chartered in 1891, having begun with three rooms in city hall in 1894. This was one of the library's original buildings.

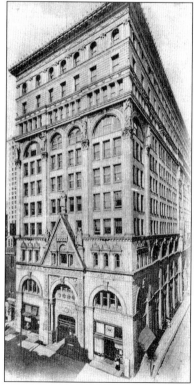

The Witherspoon building, located on Walnut Street between Juniper and Sansom Streets, was Philadelphia's first skyscraper, utilizing I-beams perfected by Andrew Carnegie. The building seen in this 1906 postcard was erected between 1895 and 1897 by William Steele and Son.

The length and breadth of east Walnut Street can be appreciated in this 1944 postcard view by K. F. Lutz. The huge building looming in the center of the photograph was the St. James Hotel.

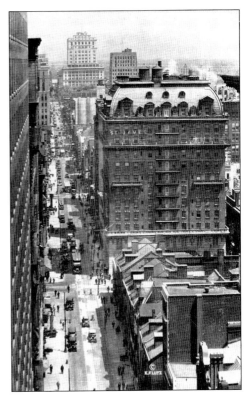

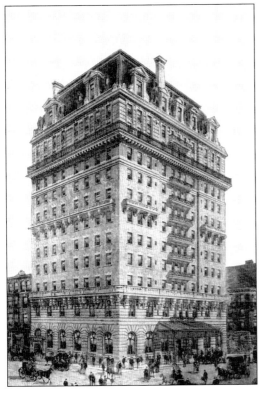

A closer view of the St. James Hotel, located at Thirteenth and Walnut Streets, is seen in this 1904 postcard view.

This panoramic view of south Thirteenth Street, shot in 1925, most likely looks down from the heights of the St. James Hotel.

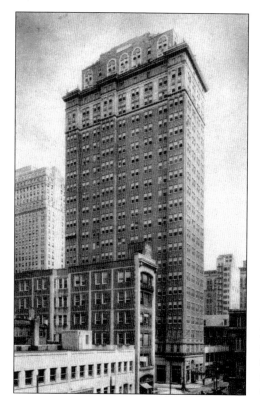

Chancellor Hall, situated on Thirteenth Street just below Walnut Street, was a 25-story high-rise that began life as an elegant apartment building. However, when seen in this 1930s view, it was advertising daily, weekly, or monthly rates. There were 400 rooms, each with a bath.

The Manufacturers' Club of Philadelphia was organized in 1887, formed for the purpose of advancing and protecting the interests of the manufacturers of the United States and bringing them into closer social contact. The building at 1409 Walnut Street, seen in this 1914 postcard, was called the organization's clubhouse.

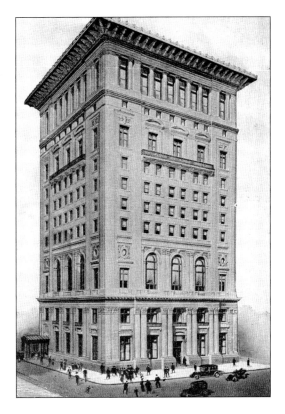

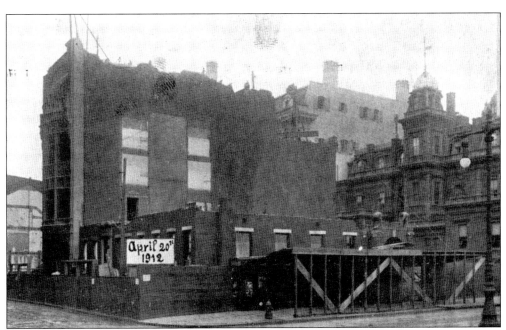

The reverse of this postcard, dated April 20, 1912, states that this was the site of the demolition of the old and erection of the new building of the Manufacturers' Club. The former Bellevue Hotel was razed to make way for the clubhouse.

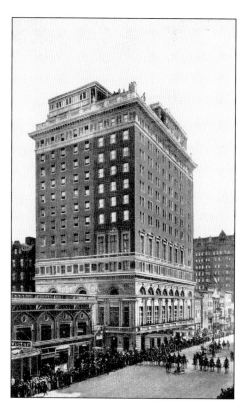

The Ritz–Carlton Hotel, located on the southeast corner of Broad and Walnut Streets, was erected in 1911 by architect Horace Trumbauer. This 1916 scene shows the Philadelphia mounted police passing in review, marching towards city hall.

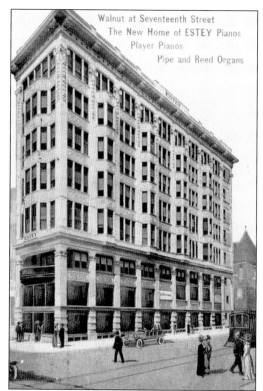

Estey Hall at 1701 Walnut Street was added to the National Register of Historic Places in 1983. Also known as the Allman building, it found its greatest usage between 1900 and 1924 by the Estey Piano Company, as seen in this 1911 postcard.

Six

THE TREE STREETS

The John T. Palmer Printing Company occupied the entire building at the corner of Fifth and Locust Streets when this card was postmarked in 1911. The printed markings on the back of the postcard, however, identify this scene as probably predating the actual postmark date.

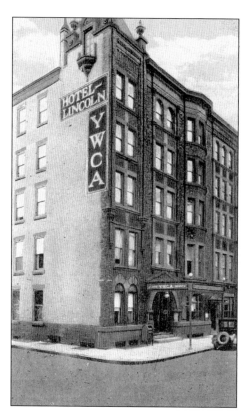

The Hotel Lincoln, located at 1222 Locust Street, is seen in this 1920s postcard. It was a hotel for business and professional women that was operated by the YWCA of Philadelphia. Like other hotels of this age, it advertised "bath or running water."

Down the street from the Hotel Lincoln and located on the northwest corner of Twelfth and Locust Streets was Otto Landenberger's Cigar Store with its window displaying its pungent wares. Next door was his Hole in the Wall, a pre-prohibition tavern.

Across the street from the Hotel Lincoln was the children's department of the Free Library of Philadelphia. The ancient building at 1233 Locust Street was in a rather dilapidated condition in this 1918 postcard.

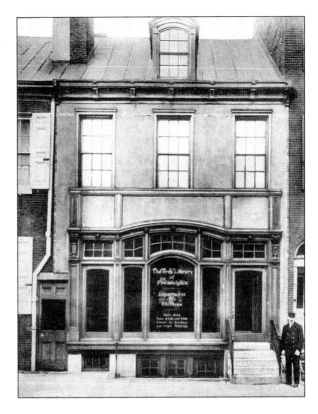

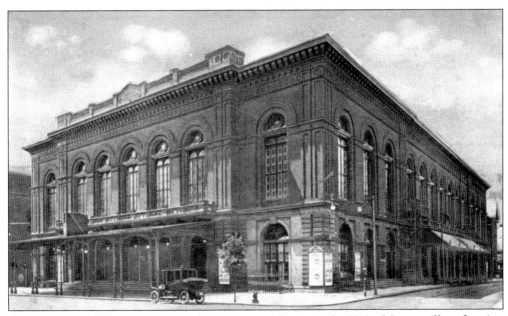

The Academy of Music remains as the oldest opera house in the United States still performing its original function. In 1857, the Broad and Locust Streets site was chosen since it was far afield from the noise of the city. This card is postmarked 1911.

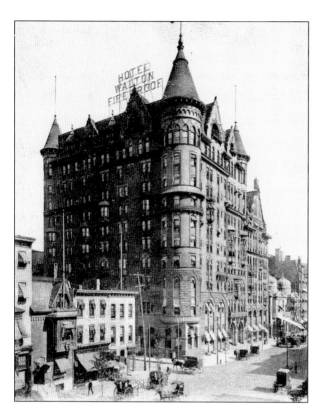

The Hotel Walton, advertised as being "absolutely fireproof," was located on the southeast corner of Broad and Locust Streets, directly across from the Academy of Music. It is seen in this 1904 postcard.

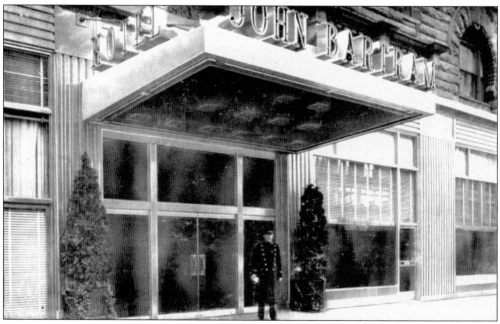

The Hotel Walton was renamed the John Bartram. In this 1940s postcard, the doorman, standing rigidly at attention, was patiently waiting for visitors to alight from their vehicles.

The Hotel Sylvania was an elegant establishment located at Juniper and Locust Streets. Max "Boo Boo" Hoff, dubbed "king of the bootleggers," ran his operation from a second-floor suite in this hotel in 1928, the year that this card was postmarked.

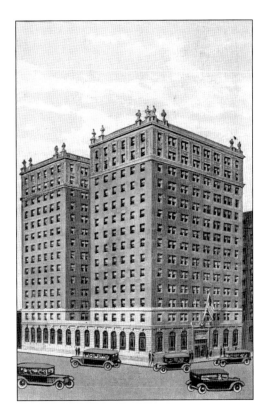

St. Mary's Roman Catholic Church, built in 1763 by master carpenter Charles Johnson, is located on Fourth Street near Spruce Street. The brick facade and its cemetery dated back to 1759. The church, which is still active, is seen in this 1903 view.

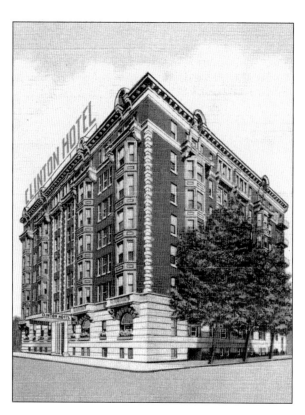

The Clinton Hotel and Apartments was located on Tenth Street below Spruce Street. Boasting 200 rooms and a roof garden, its facade appears quite elegant in this 1939 postcard.

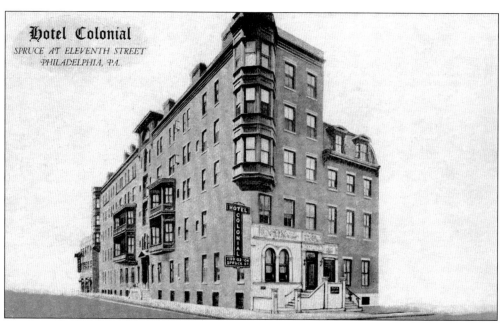

Hotel Colonial
SPRUCE AT ELEVENTH STREET
PHILADELPHIA, PA.

The Hotel Colonial, as depicted in this 1922 postcard, was located at Eleventh and Spruce Streets and was touted as "a real family hotel." It advertised that each room had either a bath or running water.

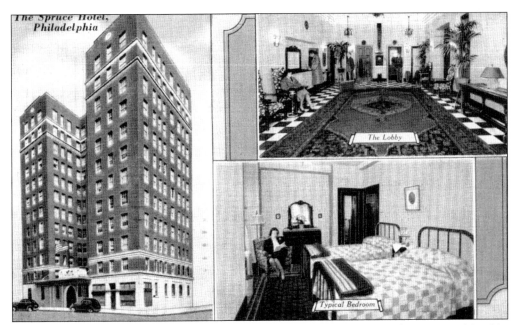

Both exterior and interior views of the Spruce Hotel, later called the Parker, are combined in this postcard dated 1938. Still in operation at Thirteenth and Spruce Streets, it is now called the Parker Spruce Hotel.

The Ethical Society of Philadelphia is currently based at Rittenhouse Square. This 1903 postcard shows the society's previous location at Spruce and Juniper Streets. The creed of the society has been "to join together in the struggle for a more peaceful world."

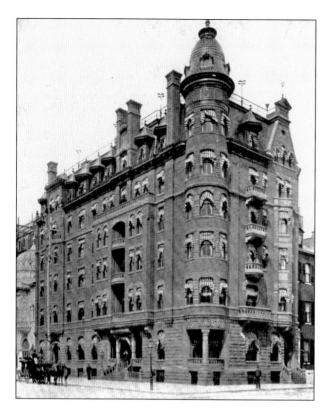

The Stenton Hotel was erected at the end of the 19th century, followed by alterations in 1916. Looming over the northeast corner of Broad and Spruce Streets, it is seen in this postcard shortly after its grand opening.

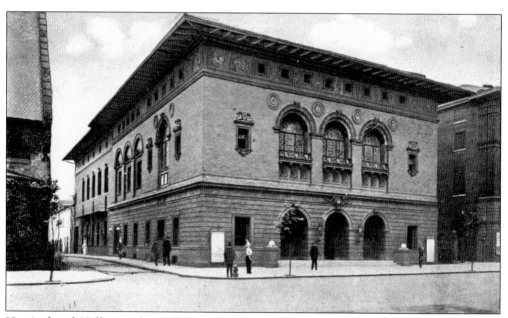

Horticultural Hall was a beautifully constructed building erected in 1896, located on Broad Street just above Spruce Street. It was the home of the Association of Philadelphians for the Advancement of Horticultural Interests. It is seen in all of its glory in this 1911 postcard. It was demolished in 1918.

The 25-story Atlantic building, of later vintage than Horticultural Hall, is still located on the northwest corner of Broad and Spruce Streets. Erected in the 1920s for the Atlantic Richfield Refining Company, it was given to the Philadelphia College of Art in the early 1980s. The postcard is dated 1927.

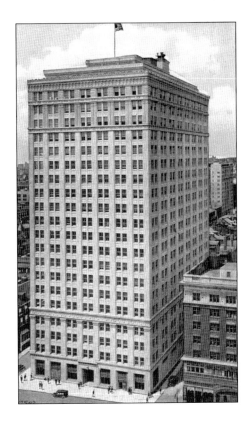

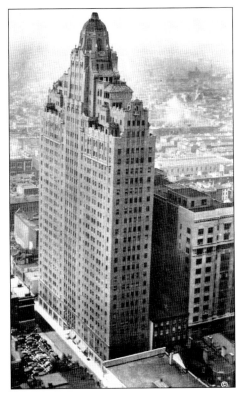

The Drake Hotel on Spruce Street near Fifteenth Street, looking not unlike the apartment house in the movie *Ghost Busters*, is seen in this 1936 panoramic view. Constructed in the 1920s by architects Verus T. Ritter and Howell L. Shay, it was Philadelphia's largest building with 753 rooms for use as apartments and hotel lodging. The Drake Hotel remains today a luxury apartment and condominium building.

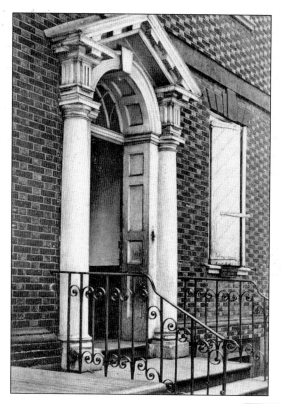

In its heyday, Pine Street was home to many of Philadelphia's prominent citizens. This postcard records the entrance to the dwelling that was built in 1750 at 224 Pine Street (replaced by late-20th-century housing).

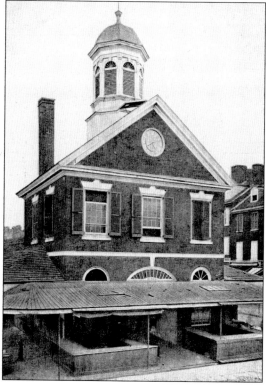

Within the same block at Second and Pine Streets were the old market sheds built in 1745. The head house, seen in this 1902 postcard, was added about 1800. Fire trucks were kept within the building, and a rooftop lookout tower was used for spotting conflagrations. The building was tastefully restored in 1960.

St. Peter's Protestant Episcopal Church, located at Third and Pine Streets, is one of the older churches still in existence. Under the directorship of Christ Church, it was erected between 1758 and 1761. George Washington and Benjamin Franklin were often seen here.

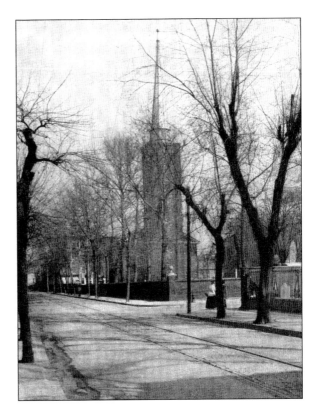

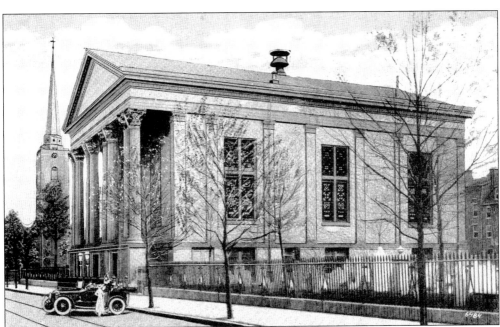

The Old Pine Street Church on Fourth Street was built in 1837 in the Greek Revival tradition, one of its walls being from the original 1768 structure. Postmarked in 1919, the spire of St. Peter's Protestant Episcopal Church can be seen in the background.

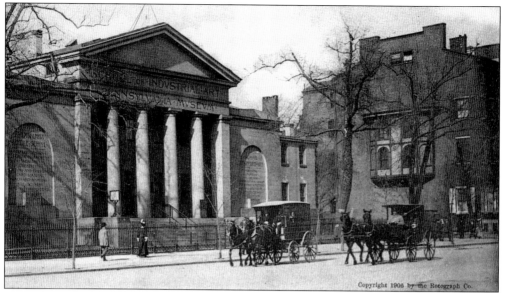

The building seen in this 1906 postcard, located at Broad and Pine Streets, designed in 1824 by architect John Haviland, was originally known as the Pennsylvania Institution for the Deaf and Dumb. It was then occupied in 1893 by the School of Industrial Art of Pennsylvania. In 1983, it became the University of the Arts.

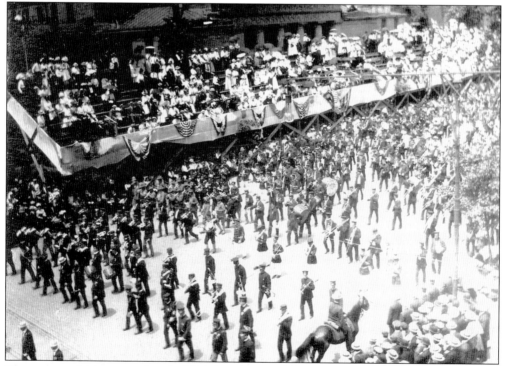

The reverse of this postcard reads "This is a picture of the Massed Band Parade in Philadelphia during the Elk's reunion taken from the window corner Pine and Broad Streets, July 16, 1907." The columns of the building seen in the upper center background were those of the School of Industrial Art.

Seven

North of
Market Street

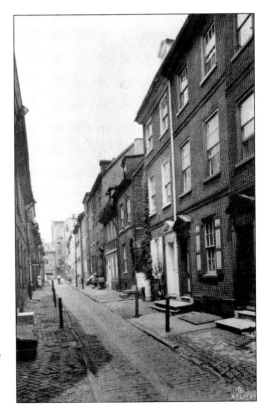

Elfreth's Alley is located between Front and Second Street, north of Arch Street. K. F. Lutz recorded its well-preserved condition in this 1939 view. The homes on this street have been continuously occupied since Colonial times. The word "alley" once carried the connotation of a polite residential area.

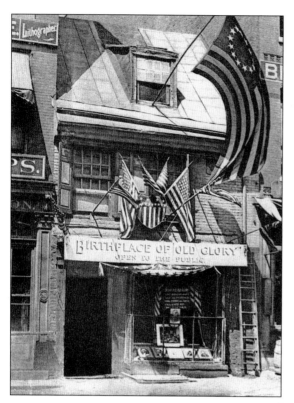

The most famous house on Arch Street remains standing at number 239. Rented by Betsy and John Ross between 1773 and 1786, it has always been touted as the place where Betsy sewed the first American flag. It is seen in this postcard dated 1905.

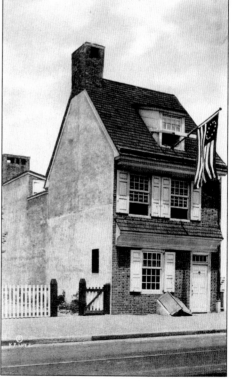

A strikingly different facade was offered in this 1938 real-photo postcard view of the Betsy Ross House. The national shrine has undergone numerous face lifts since 1918.

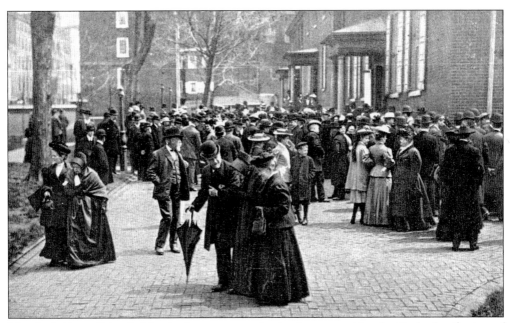

The Arch Street Friends Meetinghouse was an institution erected by the Orthodox faction of Quakers between 1803 and 1811. This 1912 postcard shows the congregation on a busy first day of the week.

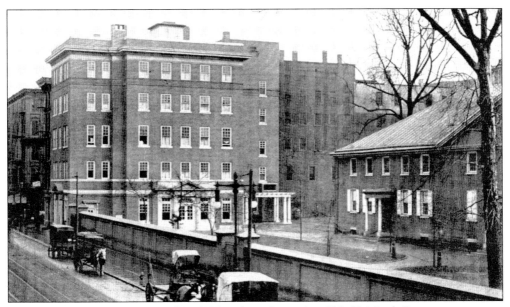

The Friends' Center was erected in 1915 and was located at 302–304 Arch Street.

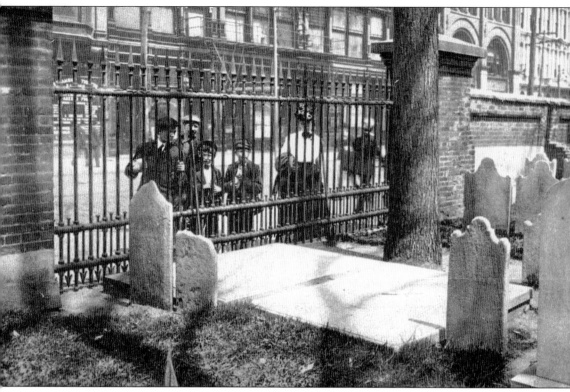

Benjamin Franklin was interred in the Christ Church graveyard at Fifth and Arch Streets, as seen in this 1908 postcard. He wrote his own epitaph: "The Body of B. Franklin Printer, (Like the Cover of an old Book Its Contents torn out And stript of its Lettering & Gilding) Lies here, Food for Worms. But the Work shall not be lost; For it will, (as he believ'd) appear once more, In a new and more elegant Edition Revised and corrected, By the Author."

The Reliance Manufacturing Company, which was located at 1318 Arch Street, boasted the largest inventory of gas and electric fixtures. The display window in this postcard dated 1910 shows fashionable electric lamps that were, at the time, "the cat's meow."

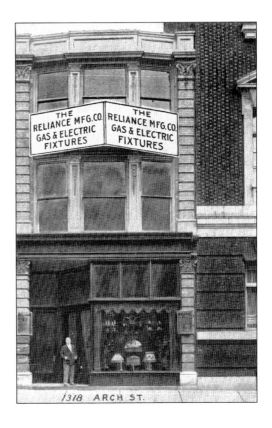

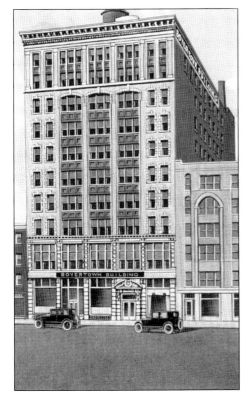

The factory complex of the Boyertown Burial Casket Company was located in Berks County. However, its main showroom, the Boyertown Building, was situated at 1211–1217 Arch Street. It is seen in this postcard view from the mid-1920s.

The 10-story Peoples Trust building at Twelfth and Arch Streets, viewed in this 1908 postcard, towered above its neighboring residential buildings.

A panoramic view of Broad and Arch Streets can be seen in this 1920s card. The taller building was the United Gas Improvement Company with the central branch of the YMCA to its left. The dome of the Cathedral of Saints Peter and Paul is visible to the far left.

Additions to the original 1908 central branch of the YMCA were made in 1929. The new building housed 1,283 single persons and 55 married couples. Some indication of the postcard's date can be deduced from the fact that the grass plot in the foreground was being trimmed by horse power.

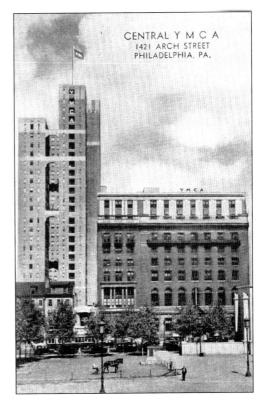

CENTRAL Y M C A
1421 ARCH STREET
PHILADELPHIA, PA.

This 1929 postcard shows the new 15-story Robert Morris Hotel, located at Seventeenth and Arch Streets. It advertised that each room had a bath and radio reception. It is presently used as an office building.

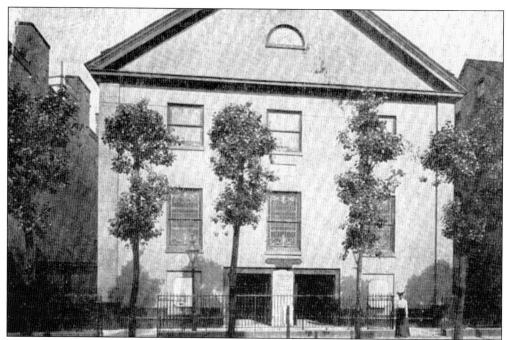

St. George's Methodist Episcopal Church, seen in this 1908 view, survives as the oldest Methodist church in the world. Prior to 1920, plans for the erection of the Delaware River Bridge included demolition of the church. However, protests and petitions were successful in saving the building, located on north Fourth Street, between Race and Vine Streets.

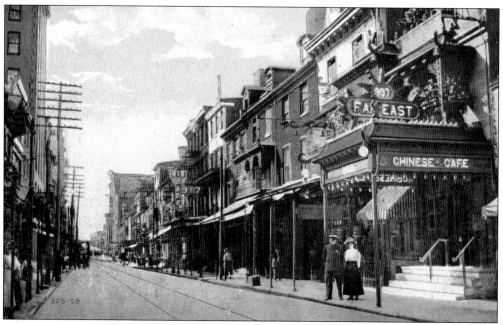

Philadelphia's Chinatown is located between Arch and Vine Streets and from Eighth to Eleventh Streets. Fong's Laundry was the first Chinese business in the area. The Mei-Hsian Lou Restaurant opened in 1870 at the same site. Race Street, Chinatown's main thoroughfare, is captured in this 1907 view.

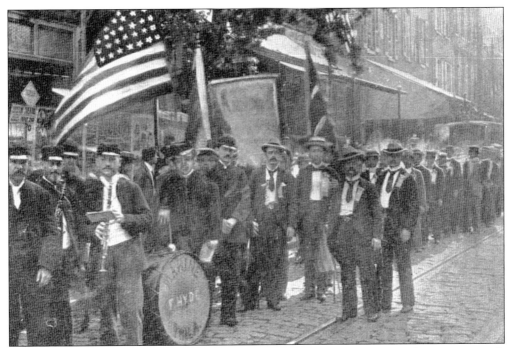

Reverend Fred Poole's Band is seen queuing along Chinatown's Race Street in this 1902 postcard. Many missionaries and progressive reformers attempted to "inculcate proper domesticity" in Chinatowns throughout the country.

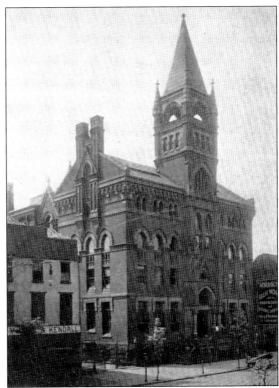

In 1807, Christian F. S. Hahnemann coined the term "homeopathy." Homeopathic theory was that a remedy diluted with water still retained a memory of the original medication. The Hahnemann Medical College, founded in 1848, was the first homeopathic institution in the world and was located at Broad and Race Streets, as seen in this 1902 postcard.

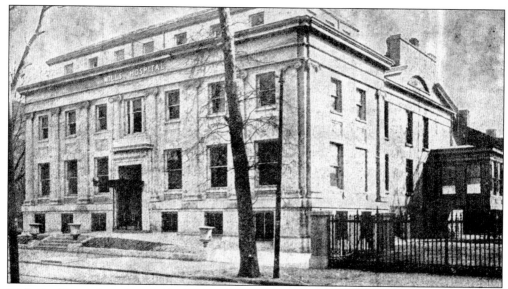

Wills Eye Hospital was founded in 1832 by the bequest of James Wills Jr., who was not a physician. At that time, the total cost of the completed hospital was $57,203.69 (around $1 million in 2006 dollars). It was located on a lot between Eighteenth and Nineteenth Streets on Race Street and is seen on this card postmarked 1910.

The Sunday Breakfast Rescue Mission was opened in the 1930s. By 1942, it required more space to accommodate a chapel, shelter, and thrift store for its families. The mission's headquarters at Sixth and Vine Streets contained 800 beds. It was acquired by the city in 1974 and eventually shut down.

Eight

Give My Regards to Broad Street

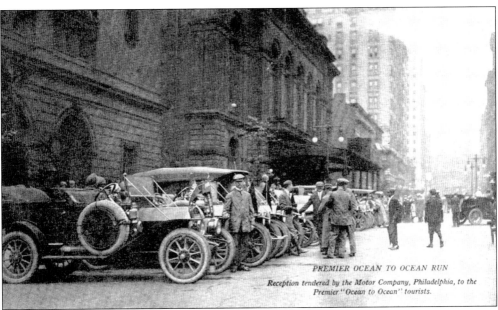

PREMIER OCEAN TO OCEAN RUN

Reception tendered by the Motor Company, Philadelphia, to the
Premier "Ocean to Ocean" tourists.

Race drivers waited impatiently for the flag to start this gala "premier ocean to ocean run." The scene opened in front of Horticultural Hall and the Academy of Music, on the west side of Broad Street between Spruce and Locust Streets. Although no exact date was given, these magnificent vehicles must have been manufactured prior to 1918, since Horticultural Hall was demolished in that year. City hall is in the far background.

Broad Street is seen here as a placid walkway with several couples strolling down the middle of the avenue. The old Bellevue Hotel is still standing on the far left, but a sign advertised that it had offices and rooms for rent. Construction is underway on the east side (right forefront) at Broad and Sansom Streets.

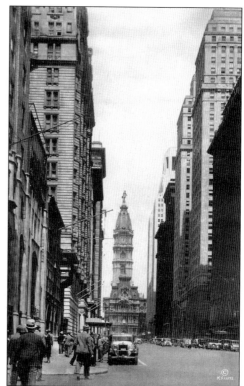

In 1936, K. F. Lutz captured a photograph from a similar viewpoint. Notice how the landscape had changed. Broad Street was now part of the heart of the business district.

106

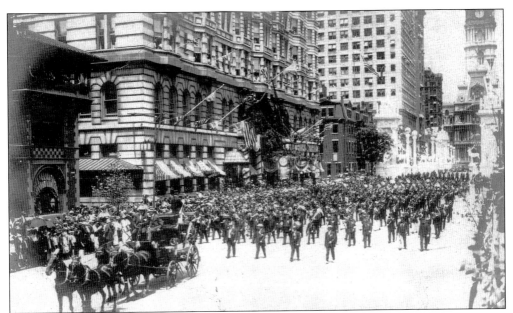

Philadelphia became quite the convention city in the early part of the 20th century. When the Elks convention came to town in 1907, north and south Broad Streets, as well as Market and Chestnut Streets, were ornately decorated. A marching band is seen passing before the reviewing stand opposite the Bellevue Stratford.

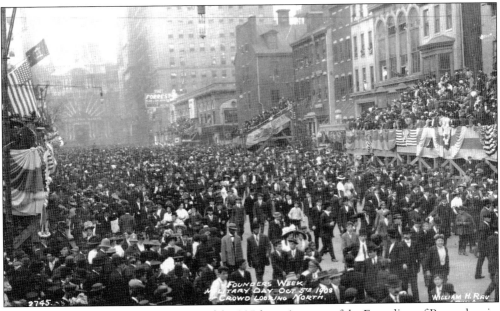

The following year was the celebration of the 225th anniversary of the Founding of Pennsylvania. On October 5, 1908, massive crowds jostled about south Broad Street on Military Day. Watch out for pickpockets!

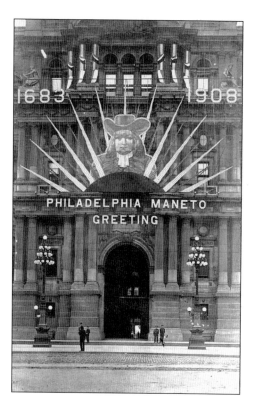

Even city hall was festooned for the gala 1908 Founders' Week. "Philadelphia Maneto" meant "let brotherly love continue," words supposedly spoken by William Penn.

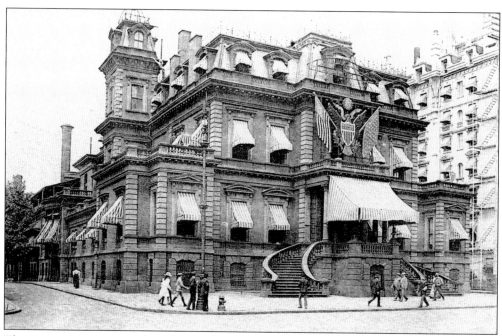

The Union League, located on the southwest corner of Broad and Sansom Streets, was a club formed to support Abraham Lincoln and the Union. It was erected in 1865 and was constructed of red brick and brownstone after the plan of architect John Fraser.

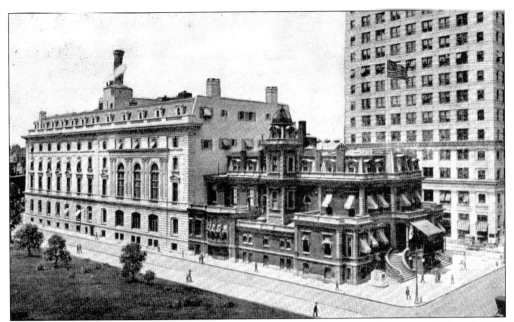

Horace Trumbauer, master architect, created the Union League annex between 1909 and 1911. The entire Sansom Street property, extending from Broad to Fifteenth Streets can be seen in this postcard view.

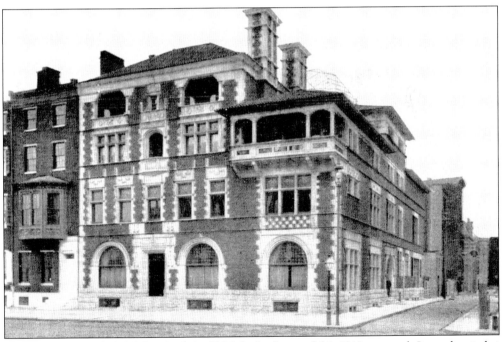

The Art Club of Philadelphia, built in 1886, is the focus of this 1911 postcard. It was located at Broad and Chancellor Streets next to the Bellevue Stratford. The club's membership included artists and prominent businessmen. It was later purchased by the Keystone Automobile Association and finally torn down in 1975 to make way for a parking lot.

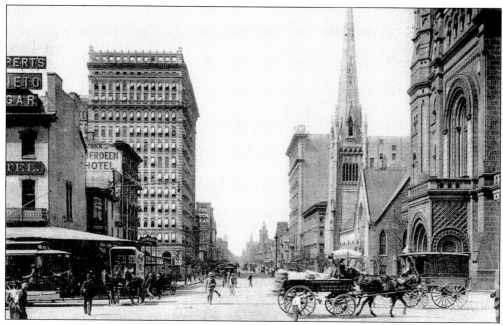

North Broad Street is seen in this view from city hall in 1900. The magnificent Masonic temple on the northeast corner of Broad and Filbert Streets stands on the far right. The Aberdeen Hotel in the left foreground had already seen better days.

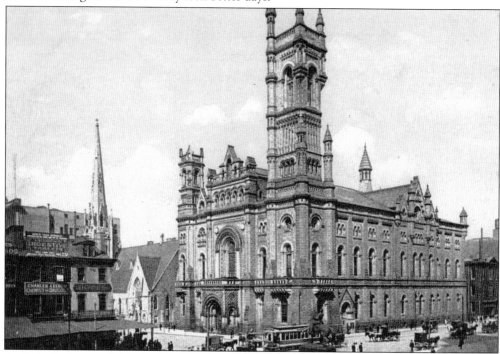

A much clearer view of the Masonic temple is captured in this 1905 view. The building, designed by James Windrim, is a colossal granite structure in the Romanesque tradition. Each of the breathtaking ceremonial rooms was created with a different motif—among them the Egyptian Hall, Norman Hall, and Ionic Hall.

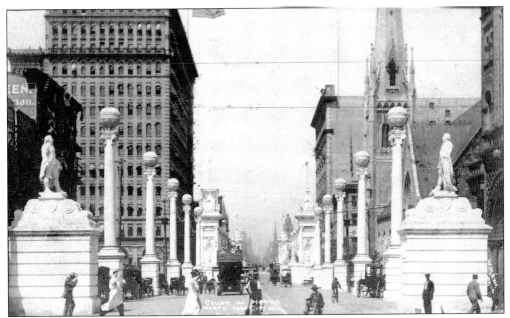

North Broad Street opposite the Masonic temple was teeming with activity during the Elks convention of 1907. Pictured here is the Court of Honor of the Patriotic Order Sons of America.

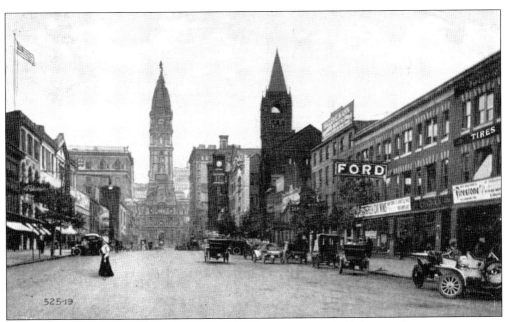

With the advent of the motorcar, Broad Street, north of city hall, became home to numerous automobile agencies, as seen in this 1911 postcard. Automobile accessory outlets were also a necessary spin-off of this burgeoning industry.

The Pennsylvania Academy of Fine Arts, located on the corner of Broad and Cherry Streets, was the first art school in the United States. One of Frank Furness's architectural masterpieces, it was built between 1872 and 1876. The academy, often called "the Louvre on Broad Street," is seen in this 1912 postcard.

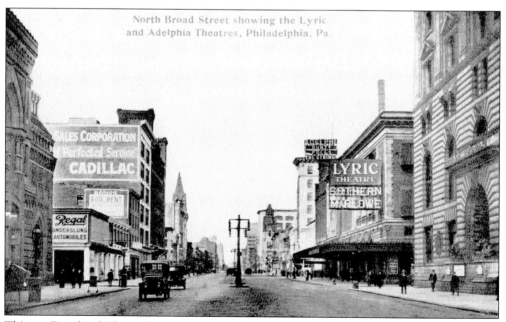

This was Broad and Cherry Streets in 1913. The Lyric Theatre and Adelphi Theater, both creations of architect James Windrim, shared a common frontage. Located across from the Pennsylvania Academy of Fine Arts, the theaters were both demolished in 1937.

Nine

RITTENHOUSE SQUARE IS COOL

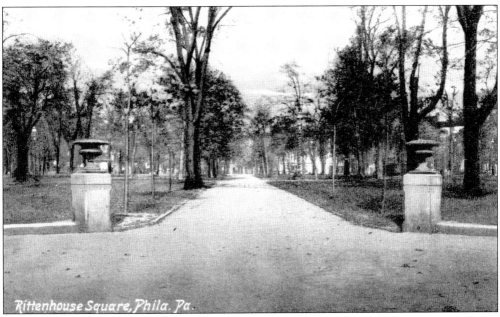

Rittenhouse Square, Phila. Pa.

In his master plan of the city, William Penn set aside five areas for public squares. Southwest Square, known today as Rittenhouse Square, was named after the Colonial scientist David Rittenhouse. Its boundaries were Eighteenth Street on the east, West Rittenhouse Square (just west of Nineteenth Street), Walnut Street on the north, and Latimer Street on the south. This 1907 postcard shows an early view of the area. The many high-rise structures surrounding it today had not yet been built.

Paul Cret, the famous architect, began the remodeling and upgrading of Rittenhouse Square in 1913. Magnificent statuary, fountains, trees, and flower beds were abound, as seen in this *c.* 1915 postcard.

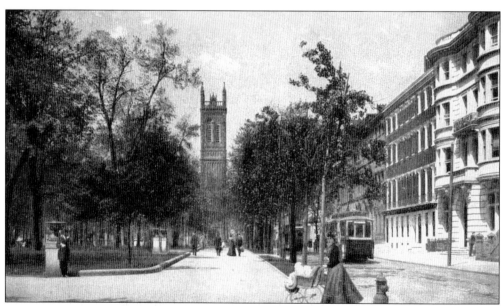

For many years the Rittenhouse Square area was home to the elite. A myriad of mansions, hotels, churches, and clubs sprang up about the periphery of the square. This 1906 view displays the stately row homes of Walnut Street. The spires of Holy Trinity Church can be seen in the background.

St. James Episcopal Church was standing at
Twenty-first and Walnut Streets in this 1910
postcard. Built in 1870, it was demolished in
1946. A gas station now occupies this corner.

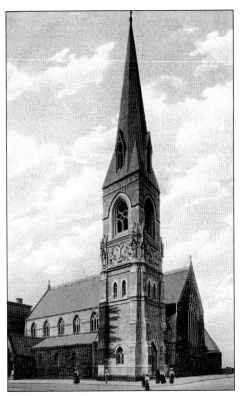

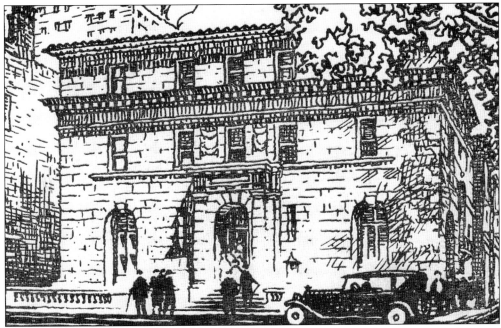

This is number 24 of the Philadelphia Art Alliance Postcard Series illustrating its building at
251 South Eighteenth Street on Rittenhouse Square. The alliance, founded in 1915 by Christine
Wetherill Stevenson, was dedicated to the cause of culture. This building was, in fact, her
childhood home.

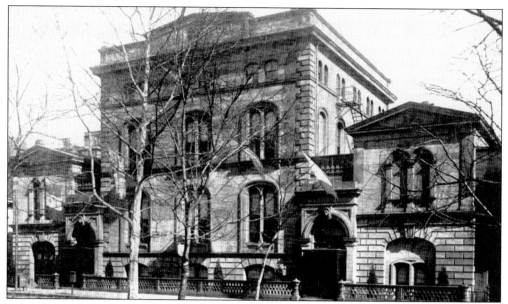

During World War I, the Army, Navy, and Marine Corps Officers Club was located within this very upscale mansion on Rittenhouse Square. Officers were offered perquisites not available to men of lesser ranks.

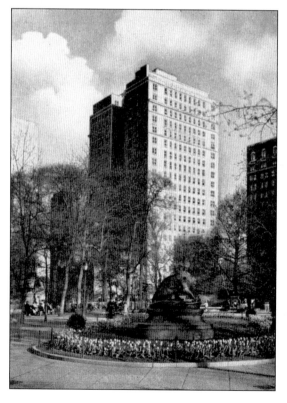

The Barclay Hotel, located on Eighteenth Street on the southeast corner of Rittenhouse Square, can be seen in the background behind Antoine Louis Barye's bronze statue *Lion Crushing a Serpent*. The Barclay Hotel has since been converted into condominiums. In 2004, its restaurant served $100 cheesesteaks made from Kobe beef.

The Wellington, a stately apartment house and hotel overlooking Rittenhouse Square, is located at Nineteenth and Walnut Streets. It was built in 1926 and placed on the Philadelphia Register of Historic Places in 1995.

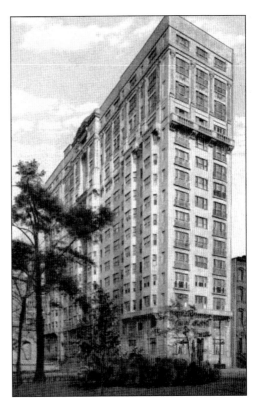

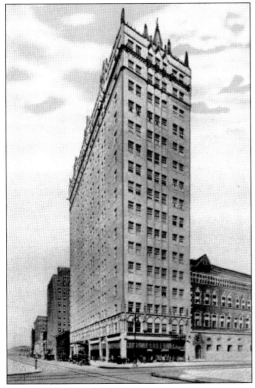

The Chatham is seen in this 1920s postcard. Located at the corner of Twentieth and Walnut Streets, it has long been a fixture rising above Rittenhouse Square.

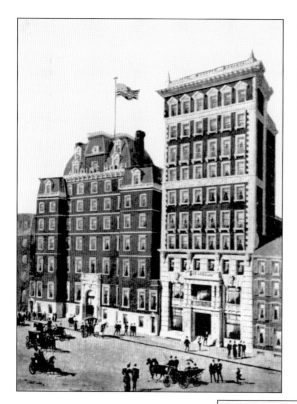

The Aldine Hotel at 1910–1922 Chestnut Street was constructed prior to 1887 and was an establishment enjoyed by middle- and upper-class clientele. The old and new sections of the hotel can be seen in this 1903 image.

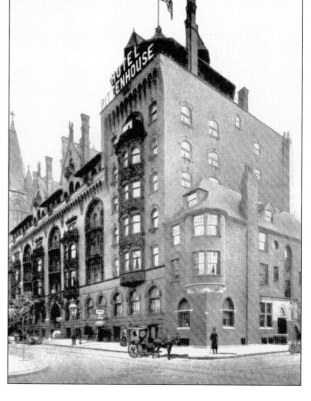

The Hotel Rittenhouse was probably the glitziest establishment on the square. This huge hotel, constructed between 1893 and 1894 by architect Angus Wade, was located at Twenty-second and Chestnut Streets. It is pictured here during its glory days in this 1898 private mailing card.

Ten

THE PARKWAY

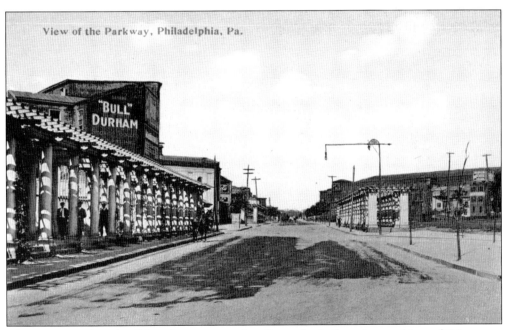

The creation of a splendid parkway emanating from city hall to the outskirts of Fairmount Park was first mentioned in an unsigned pamphlet in 1871. It was not until 1903 that, after much political machination, a city ordinance became reality, authorizing such a monumental task. The undertaking of this mammoth project, eventually to cost $30 million, would necessitate the destruction of all public and private structures in the path of the boulevard, first named the Fairmount Parkway. This *c.* 1917 postcard showed the parkway still sporting its unsightly billboards.

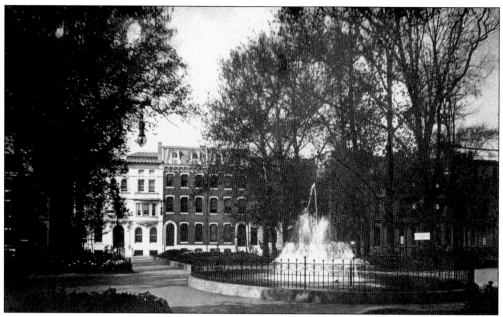

The parkway landscape, designed by Jacques Auguste Greber, was regarded as the equivalent of the Champs d'Elysee in Paris. Greber changed the configuration of Logan Square to a circle. This 1906 view of Logan Square shows a group of homes destined for removal to make way for the parkway. Logan Square was also the site of the Civil War's Sanitary Fair of 1864.

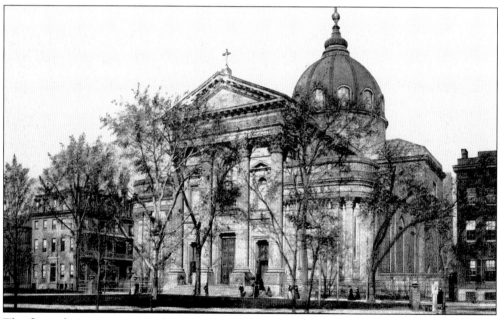

The first religious service at the Cathedral of Saints Peter and Paul was held in 1863. Built of brownstone in the Italian High Renaissance style, it faces Logan Square. The cathedral is the seat of the Roman Catholic archdiocese of Philadelphia. Its crypt contains many local church notables.

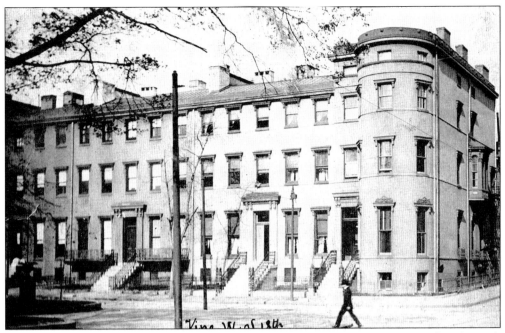

Prior to the razing of the buildings for the parkway project, the intersection of Eighteenth and Vine Streets was an elegant residential neighborhood, as seen in this real-photo postcard postmarked 1902.

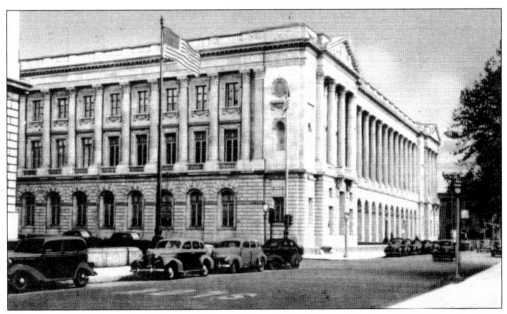

The Municipal Court building at Eighteenth and Vine Streets is viewed in this early 1930s postcard. The court building is of the same exterior French Renaissance style as the Free Library Philadelphia, as seen on page 122.

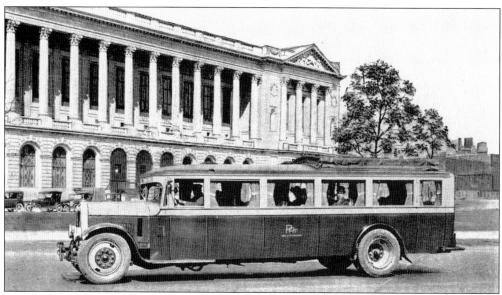

A Mitten Management Gas Electric Motorbus stands in front of the Free Library of Philadelphia at Vine Street, between Nineteenth and Twentieth Streets. The building was designed in the French Renaissance style, closely resembling the Ministry of Marine building in Paris. Opened in 1927 at a cost of $6.3 million (around $69.5 million in 2006 dollars) it houses an enormous reference department, a library for the blind, and huge music, law, and antique prints departments.

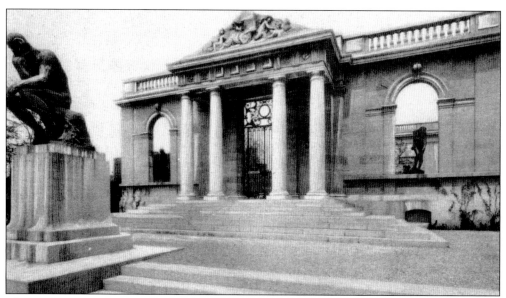

The Rodin Museum, at the north corner of Twenty-second Street and the parkway, was a gift to Philadelphians from movie theater magnate Jules Mastbaum. French architects Paul Cret and Jacques Greber designed the museum in French Renaissance style. A bronze replica of Auguste Rodin's famous *The Thinker* sits outside the main entrance, as seen in this 1940s postcard.

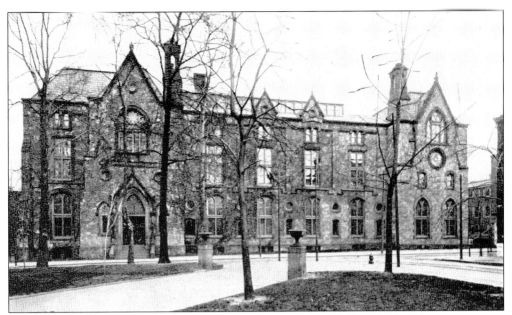

The concept of the Academy of Natural Sciences evolved in 1812 by a group of naturalists. The academy moved to Nineteenth and Race Streets in 1876 at the time of the centennial exposition. This card, postmarked in 1914, shows the original, drab exterior facade.

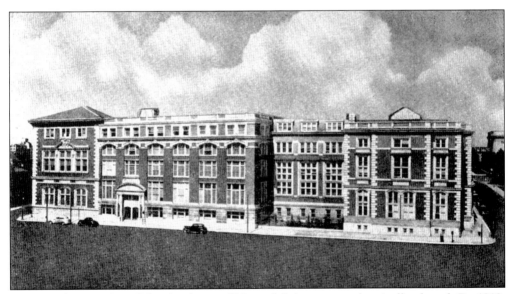

In 1905, the exterior of the Academy of Natural Sciences was drastically altered. By 1910, the facade was adorned with red brick and marble trim. The academy's extensive collections include magnificently mounted wildlife, many extremely rare; a mineralogical hall; and a giant 100-million-year-old hadrosaurus skeleton.

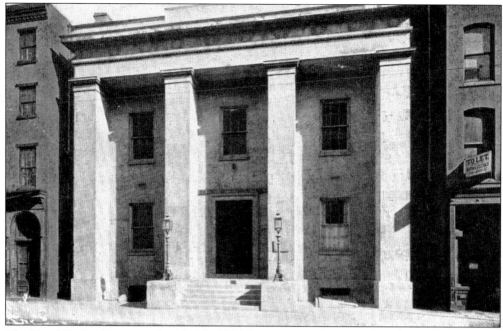

The Franklin Institute was founded in 1824 by a group of citizens keenly interested in the promotion of the sciences and mechanical arts. Its first building, as seen in this *c.* 1905 postcard, was located on Seventh Street south of Market Street. The building now houses the Atwater Kent Museum of Philadelphia History.

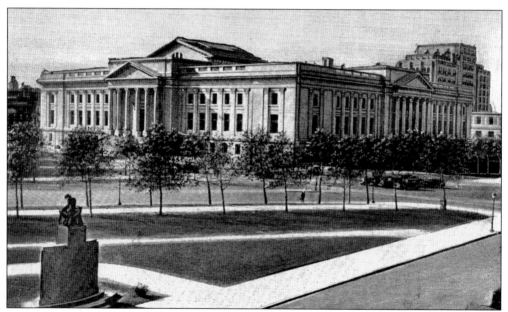

In 1933, the Franklin Institute moved to its present site at Twentieth Street and the parkway. Architect John T. Windrim modeled the building's classical design after the Deutsches Museum of Munich. A 350-ton locomotive built by Philadelphia's Baldwin Locomotive Works and named *60,000* was delivered to the institute by tracks laid down in the city streets and extending into the interior of the building.

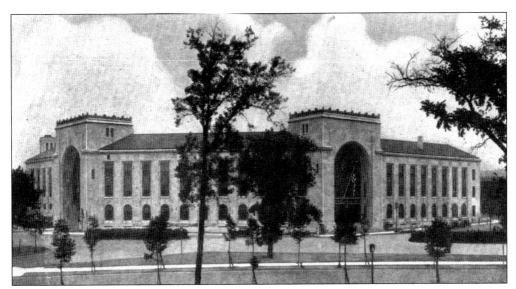

The Fidelity Mutual Life Insurance building, located on Pennsylvania Avenue across from the Philadelphia Art Museum, was erected in 1927. Designed in art deco style, its imposing bronze screens protect the front doors. The Philadelphia Museum of Art acquired the building in 1999 and has completely renovated the interior to house its library and archives, as well as some of its outstanding collections.

On an island in front of the art museum is the brilliantly executed equestrian statue of George Washington by Rudolph Siemering, erected in 1896 by the State Society of the Cincinnati of Pennsylvania. The dwellings and church seen in the background in this 1905 view had not yet been demolished as part of the parkway project.

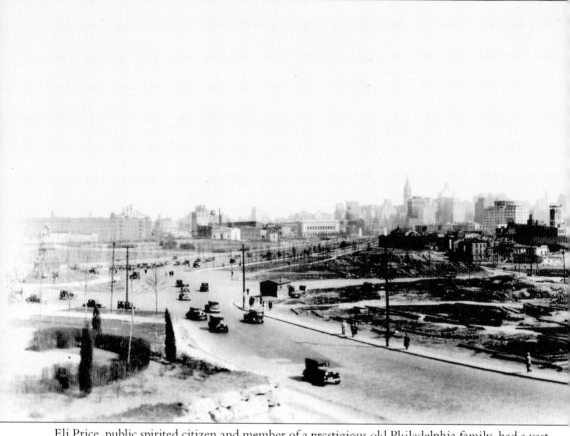

Eli Price, public spirited citizen and member of a prestigious old Philadelphia family, had a vast interest in the beautification of the city. In 1912, as a member of the city park commission, he made it his goal to situate upon Fairmount, the site of the city's reservoir and terminus of the parkway, an edifice that would become the city's resplendent pièce de résistance. It was not until after World War I in 1924, however, that the terracing of the hill, the foundations, and the steps

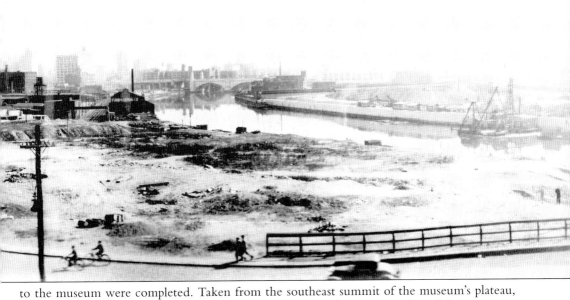

to the museum were completed. Taken from the southeast summit of the museum's plateau, this panoramic view graphically demonstrates the extent of preparatory demolition necessary to complete the museum and the parkway project. The Schuylkill River meanders along the right side of the photograph. It would be many years in the future before Rocky Balboa would be seen running up the steps of the museum.

ACROSS AMERICA, PEOPLE ARE DISCOVERING
SOMETHING WONDERFUL. *THEIR HERITAGE.*

Arcadia Publishing is the leading local history publisher in the United States. With more than 3,000 titles in print and hundreds of new titles released every year, Arcadia has extensive specialized experience chronicling the history of communities and celebrating America's hidden stories, bringing to life the people, places, and events from the past. To discover the history of other communities across the nation, please visit:

www.arcadiapublishing.com

Customized search tools allow you to find regional history books about the town where you grew up, the cities where your friends and family live, the town where your parents met, or even that retirement spot you've been dreaming about.